THE
GREGORY
GIFT

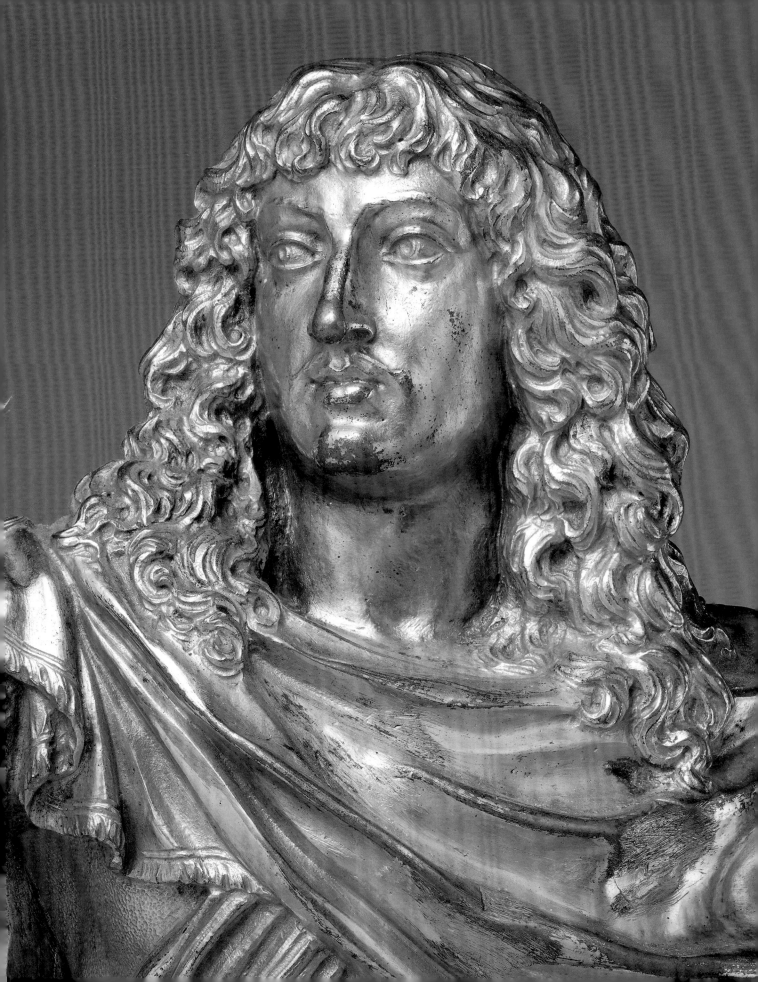

THE GREGORY GIFT

Marie-Laure Buku Pongo

The Frick Collection, New York
in association with Paul Holberton Publishing

This catalogue is published on the occasion of *The Gregory Gift*,
an exhibition on view at Frick Madison, the temporary home of The Frick Collection,
from February 16 to July 9, 2023.

This exhibition is generously funded by the Alexis Gregory Foundation.

First published in 2023 by The Frick Collection
1 East 70th Street
New York, NY 10021
www.frick.org

Michaelyn Mitchell, Editor in Chief

In association with Paul Holberton Publishing, London
www.paulholberton.com

Designed by Laura Parker

Front cover: James Cox (ca. 1723–1800), *Musical Automaton Rhinoceros Clock*, ca. 1765–72
 (cat. 28)
Back cover: Master I.C., probably Jean de Court (act. 1541–83) or Jean Court (act. 1553–85),
 Plaque: *Jupiter under a Canopy* (detail), Limoges, 16th century (cat. 4)
Frontispiece: Attributed to Domenico Cucci (ca. 1635–1705) and workshop, *Figure of Louis XIV*
 (detail), Manufacture des Gobelins, Paris, 1662–64 (cat. 23)
Page 8: Attributed to Johann Heinrich Köhler (1669–1736), *Parade Clock with Cameos* (detail),
 Dresden, ca. 1700–1710 (cat. 25)
Page 10: Workshop of Pierre Reymond (1513–after 1584), Dish: *Jason Confronting the Dragon
 Guarding the Golden Fleece* (detail), Limoges, mid-16th century (cat. 8)
Page 16: Rosalba Carriera (1673–1757), *Portrait of a Woman* (detail), 1730s (cat. 26)
Page 112: Attributed to Martial Courteys (ca. 1550–1592), *Calendar Plate for May* (detail),
 Limoges, ca. 1565–75 (cat. 12)
Page 116: Suzanne de Court (act. ca. 1600), Oval Medallion: *Apollo and the Muses* (detail),
 Limoges, ca. 1600 (cat. 18)

A CIP catalogue record for this book is available from the Library of Congress.

ISBN: 978-1-913645-43-4

This edition has been printed on certified FSC® GardaMatt Ultra paper and other certified
materials.

CONTENTS

6 Director's Foreword

9 Acknowledgments

11 Introduction

16 Catalogue

110 Notes

113 Bibliography

117 Index

119 Image Credits

DIRECTOR'S FOREWORD

Alexis Gregory (1936–2020) was a man of many parts. As an author, he wrote on travel, architecture, and the Gilded Age, among other subjects. His publishing house, Vendome Press, produced elegant volumes in the fields of fine arts, music, and culture. A music lover, he founded in 2000 the Vendome Prize, an internationally recognized piano competition. Steeped in the cultures of Russia, where his parents were born, and France, where he maintained a residence, Alexis established an apartment in Manhattan that overflowed with European art from the Middle Ages through the beginning of the twentieth century.

I first met Alexis several decades ago at a Harvard symposium that honored his promised gift of Renaissance bronzes to its museum. While his holdings of sculpture were significant, I came to recognize that his collecting passion was above all for earlier decorative arts. Through our discussions over the years, he generously encouraged the Frick to consider a promised gift of some of these works. Chief among them was a group of sixteenth-century Limoges enamels painted primarily in the sober black, gray, and white tones known as grisaille. In 1916, Henry Clay Frick had chosen a group of Limoges enamels from the estate of J. P. Morgan; he admired them so much that he turned over his private office to their display. Frick's selection was nearly exclusively vividly colored examples, so the Gregory gift complements this perfectly by adding an important aspect of Limoges's production that was unrepresented at the museum.

With Alexis's participation, we handpicked other works that would enhance the Frick's collection. Among my favorites is a *biberon* fashioned by the potters of Saint-Porchaire. Exceedingly rare, this French Renaissance ceramic now completes a group that comprises an ewer bought by Frick and another ewer recently purchased by the museum. A superb ivory hilt is one of the only ivory pieces now in the museum, as well as a singular object in the tradition of arms and armor. While its cleverly intertwined animals were carved in the Baroque era, it harks back to medieval traditions of northern European art. Finally, to represent Alexis's admiration for the eighteenth century, we were fortunate to receive two splendid portraits by the foremost Italian pastel artist Rosalba Carriera (1673–1757). Although I have singled out a few highlights, every one of the twenty-eight works in the Gregory gift has an impact on our collection.

I thank this publication's author, Marie-Laure Buku Pongo, Assistant Curator of Decorative Arts. This is her first project for the Frick since joining our staff last year. Finally, I am most grateful to the Alexis Gregory Foundation—and in particular Peter and Jamee Gregory—for its generous support of this catalogue and the exhibition it accompanies. The Gregorys have encouraged this project from the beginning, and we are delighted to mount this tribute to Alexis Gregory, the distinguished collector.

IAN WARDROPPER
Anna-Maria and Stephen Kellen Director
The Frick Collection

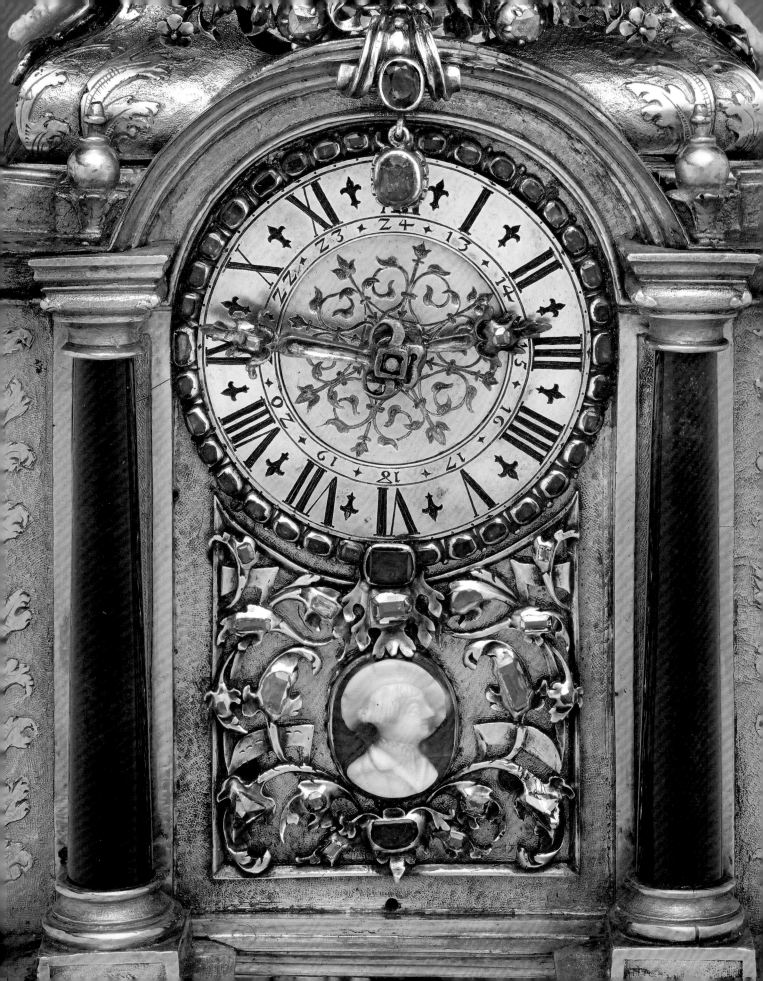

ACKNOWLEDGMENTS

I am deeply indebted to the many people who contributed to bringing this project into being. At the Frick, I am particularly grateful to Xavier F. Salomon, Aimee Ng, and Giulio Dalvit, all of whom provided critical support and invaluable input throughout the development of this publication and the exhibition it accompanies. I extend additional thanks to Xavier for writing the entries for the two lovely Rosalba Carriera pastels. I would like to acknowledge Curatorial Assistants Gemma McElroy and Rebecca Leonard, who helped enormously with my research. I am also grateful to the expert conservation team who worked on this project—Julia Day, Joseph Godla, and Gianna Puzzo—as well as to Joseph Coscia Jr. for his excellent photography of this marvelous gift. My deepest thanks go to Editor in Chief Michaelyn Mitchell, for her guidance, patience, and tremendous management of the book's production, and to former Associate Editor Christopher Snow Hopkins. I would like to express my gratitude to the exhibition team, in particular Patrick King, Christopher Roberson, Stephen Saitas, and the team at Anita Jorgensen Lighting Design. Others whose work I would like to acknowledge include Françoise Barbe, Raphael Beuing, Géraldine Bidault, Michèle Bimbenet-Privat, Jens Burk, Stéphane Castelluccio, Tia Chapman, Kee Il Choi Jr., Calin Demetrescu, Bernard Descheemaeker, Christine Desgrez, Allison Galea, Aurélie Gerbier, Paul Giraud, Dorothée and Nicolas Joly, Prince Amyn Aga Khan, Alexis Kugel, Laura Kugel, Philippe Palasi, Marie-France Pochna, Alexandre Pradère, Bertrand Rondot, Cristina de Vogüé, and Thibaut Wolvesperges.

I am particularly grateful to Ian Wardropper, Anna-Maria and Stephen Kellen Director of The Frick Collection, and the museum's board of trustees for their steadfast support. My final thanks go to Jaimee and Peter Gregory and André Gregory for their immense generosity throughout the organization of this project that celebrates Alexis Gregory's important gift to the Frick.

MARIE-LAURE BUKU PONGO
Assistant Curator of Decorative Arts
The Frick Collection

INTRODUCTION

Henry Clay Frick (1849–1919) began collecting European decorative arts late in life—as he was building his house on East 70th Street. With the help of the dealer Joseph Duveen (1869–1939) and the interior decorator Elsie de Wolfe (1865–1950), he acquired a variety of pieces to adorn his new residence. During a trip to Paris in the spring of 1914, Frick purchased several pieces of furniture and porcelain with De Wolfe as his intermediary. Later, assisted by Duveen, he procured furniture, gilt bronzes, porcelains, clocks, and carpets. Duveen also helped Frick to acquire Limoges enamels from the collection assembled by J. P. Morgan (1837–1913).

The celebrated collection of decorative arts objects amassed by Henry Clay Frick has been significantly enriched in recent decades by gifts from other collectors. In 1999, Winthrop Kellogg Edey's bequest added to the museum's holdings an important group of European clocks and watches; and in the last decade or so, gifts from Dianne Dwyer Modestini (2008), Melinda and Paul Sullivan (2016), Henry Arnhold (2019), and Sidney R. Knafel (2021) have reshaped the Frick's holdings of European ceramics with significant groups of Du Paquier and Meissen porcelain, French faience, and Italian maiolica.

The bequest from the collection of Alexis Gregory builds on this tradition by enhancing the museum's existing holdings with twenty-eight works on paper, clocks, and Limoges enamels and introducing new types of objects to the collection, with notable works in ivory and rhinoceros horn and a gilt-bronze sculpture representing Louis XIV.

Born in 1936 in Zurich, Gregory built his career in book publishing, establishing the celebrated Vendome Press, a publisher of significant volumes on French culture and art. His contributions to and engagement in the arts included serving on art committees at several cultural institutions in the United States, including the visiting committees of European Paintings and European Sculpture and Decorative Arts at the Metropolitan Museum of Art. Gregory—who inherited his taste for art and music from his parents, Lydia and George—was not only a supporter of the fine arts but also an accomplished pianist, spending time on a number of occasions with illustrious pianists and composers such as Igor Stravinsky (1882–1971), Arthur Rubinstein (1887–1982), and Vladimir Horowitz (1903–1989) at his family's residence in New York. These encounters led Gregory to create and sponsor the Vendome Prize to support talented classical pianists in the early stages of their careers. Launched in November

2000 at the UNESCO headquarters in Paris under the patronage of Catherine Tasca, then France's Minister of Culture, the Vendome Prize was awarded in partnership with the Verbier Festival in Switzerland from 2014 to 2019. Gregory's accomplishments were widely recognized during his lifetime with numerous honors in Europe, including being named Chevalier de la Légion d'Honneur and Officier des Arts et Lettres in France, and Cavaliere al Merito della Repubblica Italiana in recognition of his service to the Italian publishing industry.

Gregory's history with the Frick began with his frequent visits to the museum as a child. On one occasion, he left the boarding school he was attending with a classmate to visit the Frick and managed to convince his friend that he lived there, as everyone seemed to know him well. At Harvard, Gregory was able to study with leading art historians. Those close to him often described him as a Renaissance man, as he spoke several languages, wrote books, traveled around the globe, and collected art. These pursuits went hand in hand, as collecting art allowed him to research objects and travel around Europe to find new acquisitions. The purchase of his first Renaissance bronze at the age of eighteen marked the starting point of his collection.

Gregory collected widely, from paintings and works on paper to bronzes and sculptures. In the 1980s, his deep interest in European decorative arts prompted him to exchange one of the Impressionist paintings he had inherited from his parents, Alfred Sisley's *L'Écluse de Saint-Mammès* (The Lock of Saint-Mammès) (1885), for an assortment of bronzes, sculptures, and Limoges enamels, as well as a watercolor. (The Sisley, later purchased by Henry W. and Marion H. Bloch, was given to the Nelson-Atkins Museum of Art in 2015.) Gregory later expanded his collection with additional sculptures, Italian bronzes, and Limoges enamels, continuing throughout his life to acquire objects from the United States and Europe. Gregory's collection echoes, in many ways, the Kunstkammers created by princes during the Renaissance, where they would not only display enamels, faience, carved ivories, automatons and clocks, and precious and mounted metalwork but also show exotic natural specimens. His apartment in New York was filled with objects—gilt bronzes, tapestries and carpets, furniture, porcelain—that dated from the sixteenth to the nineteenth century.

Among the twenty-eight objects and works on paper given by Alexis Gregory to The Frick Collection, fifteen are Limoges enamels; two objects—a figure of Christ and a Venetian dish—are enameled pieces from elsewhere; and the remaining part of the gift consists of two clocks, two ewers, a gilt-bronze sculpture, a serpentine tankard, an ivory hilt, a rhinoceros horn cup, a pomander, and two pastels.

The Saint-Porchaire ewer joins two Saint-Porchaire objects already in The Frick Collection. This addition is particularly significant as only about seventy Saint-Porchaire works exist in public and private collections today. Another ewer, probably made by a follower of Bernard Palissy

The living room of Alexis Gregory's
apartment in New York

(ca. 1509–1590), sheds light on the production made after the death of the
ceramist. The ewer is part of a limited production that still poses many
questions and is represented in only a few museums, among them, the
Metropolitan Museum of Art, the Victoria and Albert Museum, and the
Musée du Louvre.

Other highlights include the Limoges enamels: they strengthen the
museum's holdings of mostly polychrome enamels by adding a signifi-
cant number of grisaille examples, a technique developed in the sixteenth
century and often used by enamelers such as Pierre Reymond (1513–after
1584) from the 1530s. The Gregory gift includes multiple enamels made
by Reymond and his workshop and by the enameler Jean de Court (act.
1541–83) and broadens the representation of these artists at the Frick.

A large dish enameled on copper is the first of its kind to enter our
collection. It belongs to a rare production in sixteenth-century Venetian
workshops, and only about three hundred pieces exist today in private and
public collections such as the Walters Art Museum in Baltimore and the
Musée National de la Renaissance at Château d'Ecouen.

Carved ivory and rhinoceros horn objects also enter our collection
for the first time. A fine hilt in ivory, possibly made by Johann Michael

The dining room of Alexis Gregory's
apartment in New York

Maucher (1645–1701), who was one of the most important ivory carvers
and sculptors at that time and worked for emperors and princes, sheds
light on ivory carving and production in southern Germany during the
eighteenth century.

The gilt bronze representing Louis XIV (1638–1715) attributed to
Domenico Cucci (ca. 1635–1704)—one of the most talented cabinet-
makers of the eighteenth century—and his workshop is likely one of the
last remnants of a cabinet made for the king, around 1662–64. In 1883,
the Musée du Louvre tried unsuccessfully to acquire the bronze when it
came on the market. The object mostly remained in private hands before
it was acquired by Gregory in 2007. Gilt bronzes and other objects made
by Cucci and the Gobelins workshop are mostly held in private hands.
Besides the Frick, only a few museums, such as the Château de Versailles,
hold examples of these objects.

Two clocks, one made by the British jeweler and goldsmith James Cox
(ca. 1723–1800) and the second by Johann Heinrich Köhler (1669–1736),
jeweler at the court of Dresden, diversify the Frick's important holdings
of clocks and watches and are key examples of their respective types.

Both jewelers worked for powerful patrons: Köhler for Augustus II ("the Strong") (1670–1733), Elector of Saxony (r. 1694–1733) and King of Poland (r. 1697–1733), and Cox for the Chinese Qianlong emperor (1711–1799). Examples of their work are still on view in the Grünes Gewölbe (Green Vault) in Dresden and the Forbidden City in Beijing.

Gregory's bequest also brings to the Frick several works of art made by female artists. Opportunities were rare for female artists in Europe, and work by women artists is much sought after in today's market. An enameled medallion by Suzanne de Court (act. ca. 1600), the only known female artist who led a workshop in Limoges during the sixteenth century, joins a notable pair of saltcellars already in the Frick's collection and signed by the same maker. Two portraits by the celebrated Venetian pastelist Rosalba Carriera (1673–1757) significantly enhance the museum's holdings of works in the medium by Jean-Baptiste Greuze, Francis Cotes, and Elisabeth Louise Vigée-LeBrun.

Gregory was interested in the quality of the objects he acquired and the prestige of their former owners. Several objects came from distinguished collectors, including a number of Limoges enamels that belonged to the Rothschilds and were displayed at Mentmore Towers—one of the family's country houses—in Buckinghamshire, England. Other objects came from the French royal collections or were part of the collection of Nevada Stoody Hayes (1870–1941), Princess of Braganza, who inherited several heirlooms from the Crown Jewels of Portugal.

This generous and important gift to The Frick Collection opens new areas of research and lays the groundwork for exciting projects. From research into the context of their creation to technical analyses expanding our knowledge of how this group of objects was produced, Alexis Gregory's generous gift is a solid foundation on which to explore decorative arts from the sixteenth to the eighteenth centuries and complements The Frick Collection's commitment to the display of European decorative arts, begun a century ago with Frick's first acquisitions during a visit to Paris.

This introduction is partly based on a conversation between the author and Peter Gregory, Alexis Gregory's brother, which took place on May 27, 2022.

CATALOGUE

I

Dish
Venice (?), early 16th century

Enamel on copper, parcel-gilt
DIAM. 17 ½ in. (44.5 cm)

Provenance: Baron Max von Goldschmidt-
Rothschild (1843–1940), Frankfurt; by descent
to his heirs and estate; Goldschmidt-Rothschild
Collection sale, Parke-Bernet, New York, April
13–14, 1950 (lot 144?); Thomas F. Flannery Jr.
(1926–1980), Chicago; Thomas F. Flannery Jr.
Collection sale, Sotheby's Parke Bernet & Co.,
London, December 1–2, 1983 (lot 48); Kugel
Gallery, Paris; purchased by Alexis Gregory,
2004.

This large dish decorated with foliage and flowers has a central boss sur-
rounded by twelve concave gadroons in blue on a white ground. The inner
ring is made of translucent green enamel, while the outer ring is made of
opaque blue enamel with a gold frieze. The dish is decorated with twenty-
four spiral gadroons in white enamel against a deep blue ground. The
deep blue wing is ornamented with gold motifs dotted with white and
red strokes, and the thin rim is white. The reverse is also richly deco-
rated: a continuous pattern of gold stars and flowers is set in a deep blue
background. At the center of the dish is a Saxon silver coin that bears
a coat of arms and an inscription: FRAT: ET DVCES. SAXON (Brothers and
Dukes of Saxony). Engraved by Hans Biener (ca. 1556–1604), the coin was
minted in 1592. On the reverse are three brothers, two of whom became
Elector of Saxony: Christian II (r. 1591–1611), Augustus, and Johann
Georg I (r. 1611–56).[1] It is not known when the coin was added. Among
the three hundred and thirty-five dishes and objects in public and pri-
vate collections today, about fifty of them have painted coats of arms or
coins. These elements were likely added when the objects were made—a
dish in a private collection has the Latin inscription DNS BERNARDINVS DE
CARAMELLIS PLEBANVS FECIT FIERI DE ANNO MCCCCCII (Don Bernardino
de Caramellis, parish priest, had the following done in 1502)[2] and a tren-
cher at the British Museum in London has on its reverse a merchant's
mark, perhaps that of the Fugger family of merchants and bankers or a
Florentine or Tuscan family such as the Portinari and Salvati.[3] It may also
have been added by one of the successive owners, as suggested by several
examples: a ewer at the Metropolitan Museum of Art in New York bears
on its foot a coat of arms that was likely created in the nineteenth cen-
tury,[4] and a coat of arms on the inside of a cup at the Walters Art Museum
in Baltimore was mounted by the Parisian restorer Maison André in 1906.[5]

Likely meant to be displayed, this dish belongs to an extremely small
production of luxurious enameled objects—both secular and liturgical—
made in Venice between 1475 and 1550, a seventy-five-year span during
which sumptuary laws dating from the end of the fifteenth century
restricted the use of silver, limiting it to coinage.[6] The laws were rein-
forced when a conflict occurred, as was the case in 1510 during the War
of the League of Cambrai (1508–16), which was part of the Italian Wars
(1494–1559).

The forms and the decoration on this dish show similarities with
the production of metalwork and Venetian glass.[7] Several scholars have
suggested that these pieces may have been made by goldsmiths and
then enameled and decorated by glassworkers such as Zuane (Giovanni)
Ballarin (act. ca. 1512), a hypothesis based on the presence of several
enameled copper pieces in the glassworkers' posthumous inventories.[8]
Recent studies have questioned not only the role of glassworkers but
also the place of production, proposing that pieces such as this dish may
have been produced in Florence rather than Venice.[9]

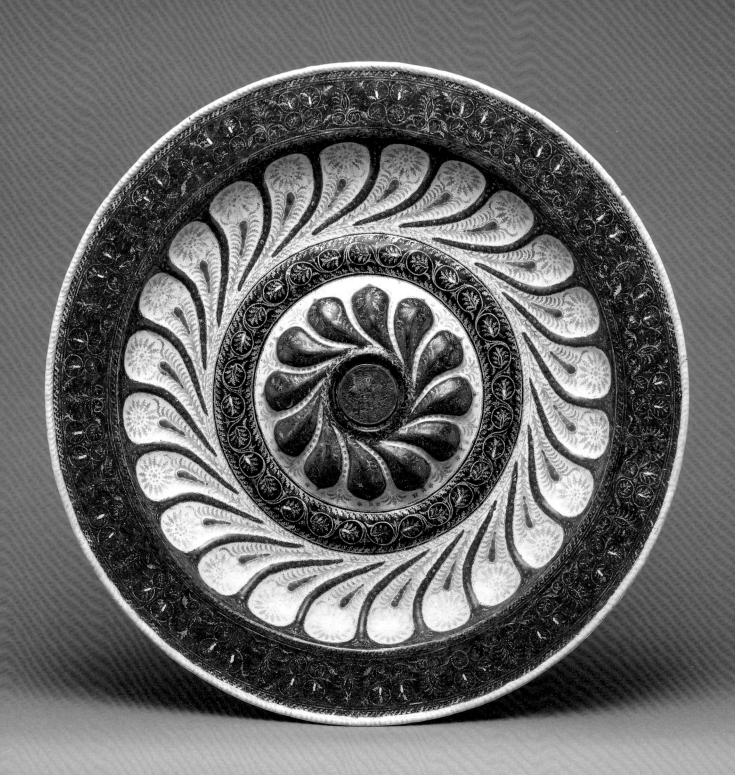

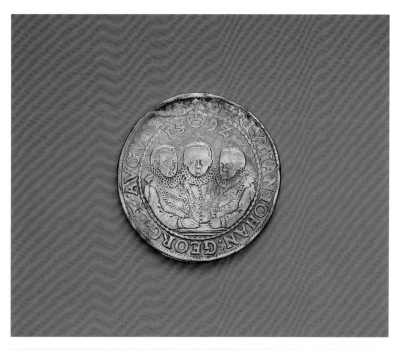

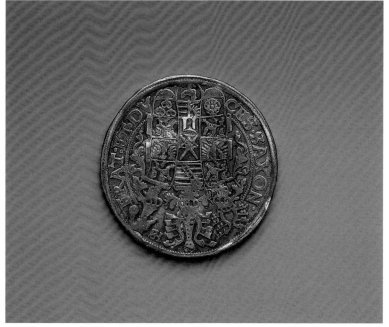

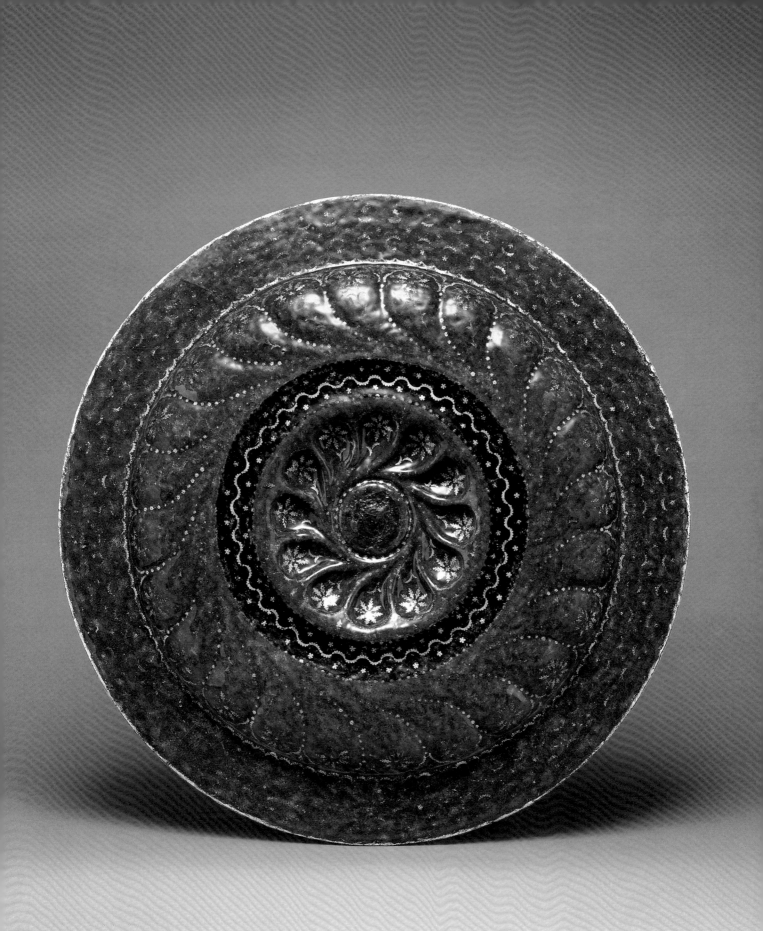

2

SAINT-PORCHAIRE WARE
Ewer (*Biberon*)
Mid-16th century

Lead-glazed earthenware
H. 8⅜ in. (21.3 cm)

Provenance: Baron Gustave de Rothschild (1829–1911), France; Baron Robert de Rothschild (1880–1946), France; Piasa sale, Drouot, Paris, June 11, 1997 (lot 59); Kugel Gallery, Paris; purchased by Alexis Gregory, 1997.

Known as a *biberon* (nursing bottle), this ewer with three handles and a spout has a complex molded, stamped, and inlaid decoration consisting of foliage, leaves, cabochons, and leonine masks. The delicate interlacing forms several intricate patterns, and a strapwork cartouche features a coat of arms consisting of three fleurs-de-lys. The *biberon* was part of a very small, yet refined, production created during the reign of Henry II of France (r. 1547–59). Called Saint-Porchaire ware, it is named after a French village—near Parthenay and Bressuire in Deux-Sèvres—in a region that was rich in kaolin, the white clay that is one of the main components of Saint-Porchaire objects. Several scholars have suggested that Saint-Porchaire ware may have been made in Paris.[10]

Archaeological excavations carried out in the late nineteenth century and 1985–90 near the Musée du Louvre—the location of the former Palais des Tuileries—revealed the presence of fragments and molds stylistically similar to Saint-Porchaire ware. The shards found in what was once the workshop of Bernard Palissy (1509–1590) are remnants of objects and pieces made for the grotto Palissy decorated for Catherine de' Medici (1519–1589) in 1570. Palissy was either imitating Saint-Porchaire production or was involved in the production.

Among the sixty to seventy pieces of Saint-Porchaire ware that remain today, a few have been attributed to Palissy, who was known for his *rustiques figulines* (rustic wares), lead-glazed ceramics made by taking casts of live animals and plants. The shapes of these objects echoed those found in goldsmithing, glassware, and enameling. Several decorative motifs and models made by artists such as Rosso Fiorentino (1494–1540), Giulio Romano (ca. 1499–1546), Etienne Delaune (ca. 1518–1583), and Jean Cousin the Elder (ca. 1490–1560)—and known from the drawings and engravings by Léonard Thiry (ca. 1500–1550) and René Boyvin (ca. 1525–ca. 1625)—reveal the links between their artistic production and Saint-Porchaire ware. The interlaced decoration with human figures and animals on the ewer shown here is reminiscent of manuscripts and engravings by the court artist Jacques Androuet du Cerceau (1510–ca. 1585/86).[11] Du Cerceau published several volumes with arabesque and moresque patterns, a testament to the exchange between the West and the East, as some of these motifs could be found in the Islamic world. Likely never used, this ewer was probably intended for display. Most of this luxurious production was destined for the royal family and important patrons such as the Montmorency-Laval family, who owned the seigneury of Bressuire.

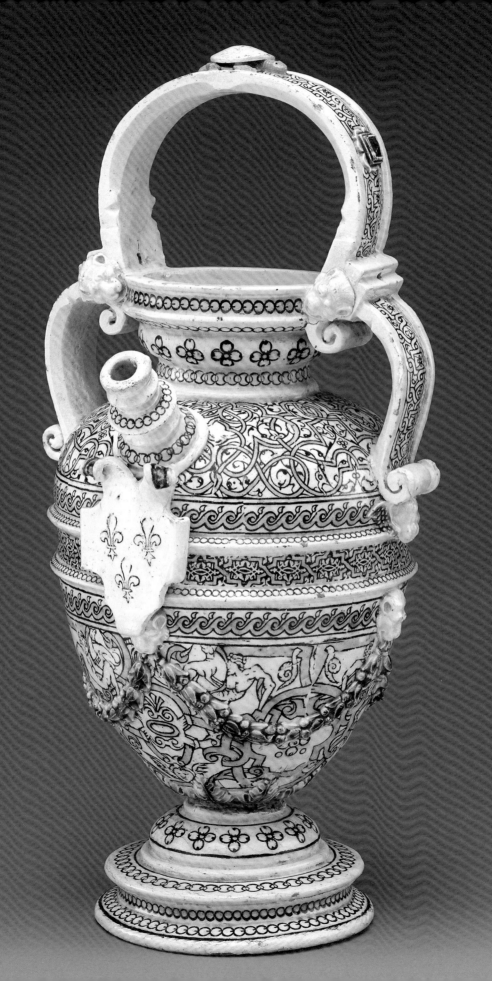

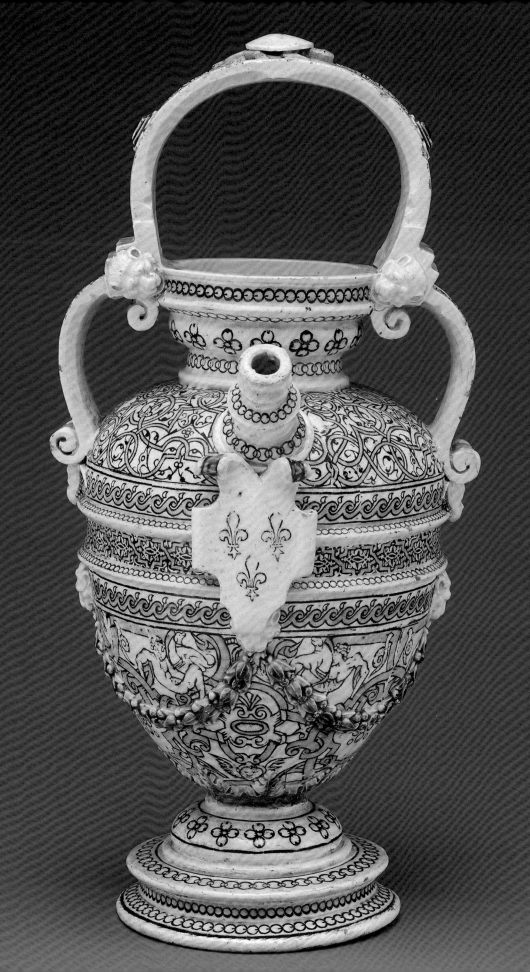

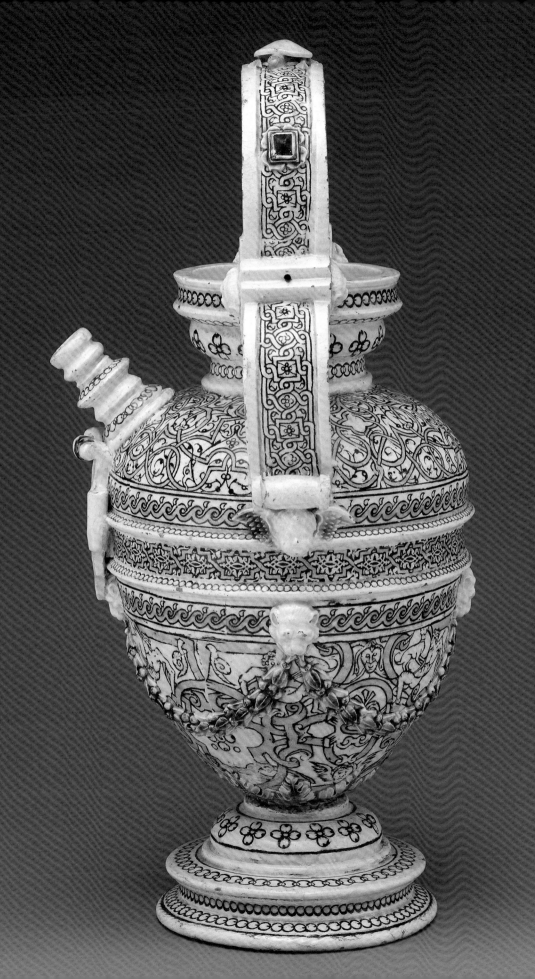

3

PIERRE REYMOND (1513–after 1584)
Saltcellar
Limoges, ca. 1545

Enamel on copper, parcel-gilt
H. 2¾ in. (7 cm), DIAM. 4 ¾ in. (12 cm)
Marks (underside): *P.R.*

Provenance: Max von Goldschmidt-Rothschild
(1843–1940), Frankfurt; by descent to his heirs
and estate; Goldschmidt-Rothschild Collection
sale, Parke-Bernet, New York, March 10–11, 1950
(lot 64?); Jan Dirven Gallery, Antwerp; purchased
by Alexis Gregory, 1999.

On the body of this saltcellar, Venus is shown seated on a chariot drawn by four doves and accompanied by putti. One of them holds a bow, a second holds the arrows, and a third putto pushes the chariot. In front of the chariot, several putti holding instruments form a triumphal procession. Four figures—one holding a gold spear in his left hand—stand near a column and a wall. On the neck of the saltcellar is a French inscription painted in gold: 1545 PRENE EN GRE (Accept this willingly).

A male portrait in the antique style is represented in the receptacle, and the rim is decorated with acanthus leaves. The composition depicting Venus's triumph derives from a Marcantonio Raimondi (ca. 1480–1534) engraving—*Quos Ego*—published about 1515–16 (fig. 1). One of Raimondi's most important works, the engraving was made after a design by Raphael (1483–1520) that illustrates episodes from the first book of Virgil's *Aeneid*. The same composition is represented on a casket—made about 1550—attributed to Pierre Reymond in the Taft Museum of Art in Cincinnati[12] and on a plaque by Jean II Pénicaud (ca. 1515–ca. 1588) at the Norfolk Museums.[13] Another literary source for the procession may be *I Trionfi* (The Triumphs), a series of poems by Petrarch (1304–1374) in which Love is described as riding on a triumphal chariot driven by four white horses heading to Cyprus, the island where Venus was supposedly born. The second scene, with four standing figures, may also illustrate an episode from Virgil's *Aeneid* in which Dido, the Queen of Carthage, receives Aeneas. This episode takes place in the fourth book, which recounts the love story between the two protagonists. Reymond and his workshop depicted the triumphal procession of Venus and the encounter of Dido and Aeneas several times. The Musée du Louvre has two saltcellars attributed to Reymond—one of them with just the Triumph of Venus—that have an identical composition.[14] The inscription is used multiple times in Reymond's works, as for instance, on a medallion at the Historisches Museum in Basel.[15] It likely refers to a poem from the *Cent Ballades* (Hundred Ballads) written between 1394 and 1399 by Christine de Pisan (1364–ca. 1430). The verse "Prenez en gré le don de vostre amant" (Accept willingly the gift of your lover) is mentioned three times in the eighty-first ballad. The inscribed poem, together with the absence of traces of use on the surface of the saltcellar, suggests that the saltcellar was part of a gift and likely never used.

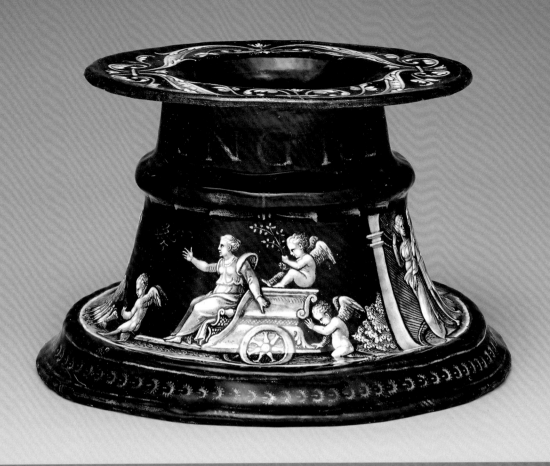
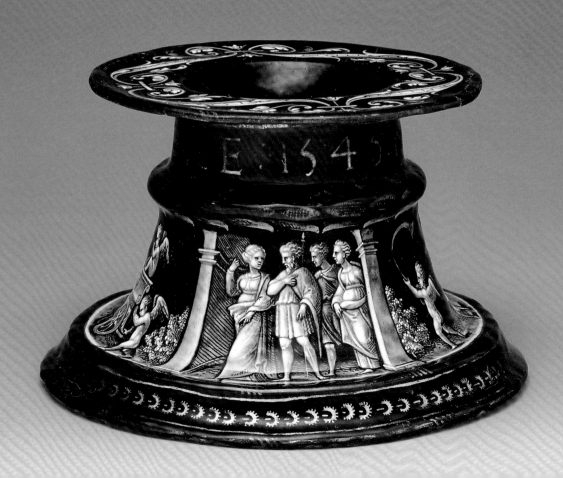

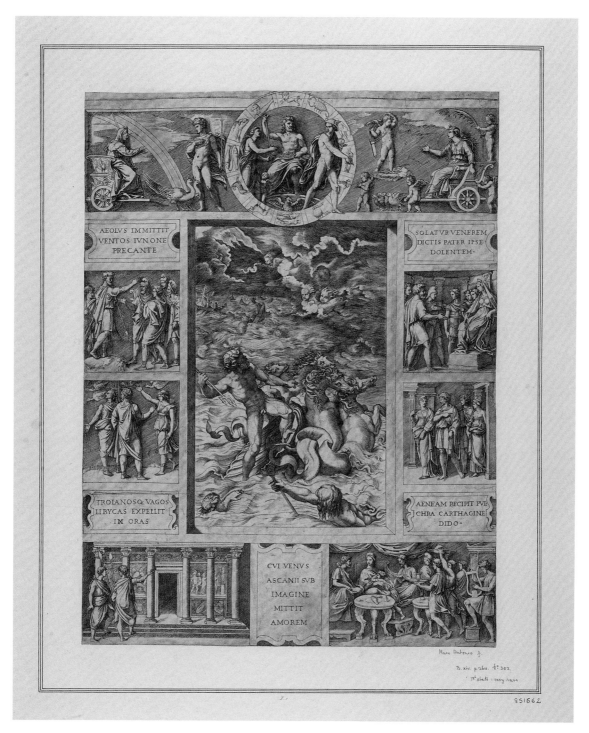

FIG. 1. Marcantonio Raimondi (ca. 1480–1534),
Quos Ego, ca. 1515–16. Engraving, 16½ × 12¾ in.
(42 × 32.6 cm). Royal Collection Trust, London;
His Majesty King Charles III 2022

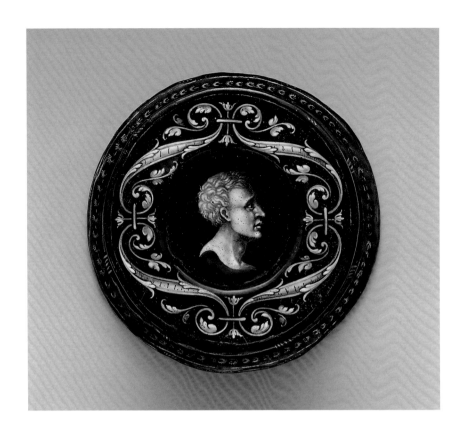

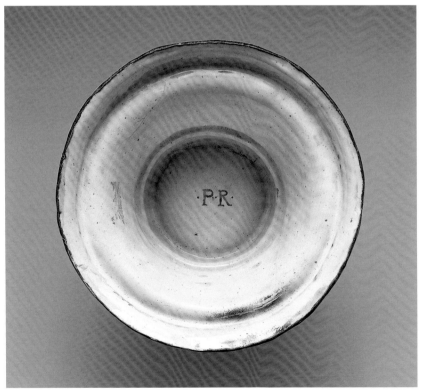

4

MASTER I.C., PROBABLY
JEAN DE COURT (act. 1541–83)
OR JEAN COURT (act. 1553–85)
Plaque: *Jupiter under a Canopy*
Limoges, 16th century

Enamel on copper, parcel-gilt
H. 4½ in. (11.5 cm), w. 3⅜ in. (8.6 cm)
Marks (above the figure of Jupiter): *I.C.*

Provenance: Victor Bacchi (d. 1975), New York;
Baron Jean Germain Léon Cassel van Doorn
(1882–1952), Englewood; sale, Christie's, London,
December 6, 1958 (lot 32); Jack (1897–1980) and
Belle Linsky (1904–1987), New York; Jan Dirven
Gallery, Antwerp; purchased by Alexis Gregory,
1996.

Standing naked under a canopy in the center of the composition of this enameled plaque, Jupiter appears triumphant. He wears a crown and holds a scepter in his left hand. The eagle, one of his attributes, is at his feet. Seated beside him are two figures—likely monks or scholars—who are reading and portrayed with asses' ears, a representation often used at the time to depict the corruption and blindness of the Catholic Church. The decorative elements include grotesques, flowers and leaves, birds and animals, and the head of a putto. The back of the case contains a mirror. The elaborate composition on the front derives from an engraving by Etienne Delaune (ca. 1518–1583), which is from a suite of grotesques with Roman divinities (*Suite de grotesques avec des divinités*) (fig. 2).[16] These engravings inspired many enamelers. The figure of Jupiter on the plaque is identical to one represented on the reverse of a dish depicting the Last Supper by Jean Reymond (d. 1602/3) in the Frick's collection.[17] The same grotesques are on the reverse of a dish—*Apollo and the Muses*—by Martial Reymond (d. 1609) also at the Frick (fig. 3).[18] The initials I.C. above the canopy in gold suggest that Jean de Court was involved in the production of the plaque. De Court, who seldom dated his work, used to also sign with the initials I.C. or I.D.C.[19] He has also been associated with Jean Court dit Vigier (act. ca. 1555–58), who used the initials I.C.D.V. Some scholars have suggested that Jean de Court and Jean de Court dit Vigier might be the same person. Archival documents suggest that the names were interchangeable at that time, which would explain why the enamels signed under his name appear during such a brief period.[20] Some, however, distinguish between the two names.[21] An ode written by the poet Joachim Blanchon (ca. 1553–1597?), and published in 1583, mentions the names of Court, Vigier, and Courteys.[22] Very little is known about the life of Jean de Court: he could have been painter to Charles de Bourbon, Prince de la Roche-sur-Yon (1515–1565) in 1553, and to Mary, Queen of Scots (r. 1542–67) and consort of Francis II of France (r. 1559–60), between 1562 and 1567, before succeeding François Clouet (ca. 1510–1572) as painter to Charles IX of France (r. 1560–74) in 1572.[23] Notwithstanding debates among scholars and the ongoing research on his life and production, he remains one of the most prolific enamelers of the sixteenth century.

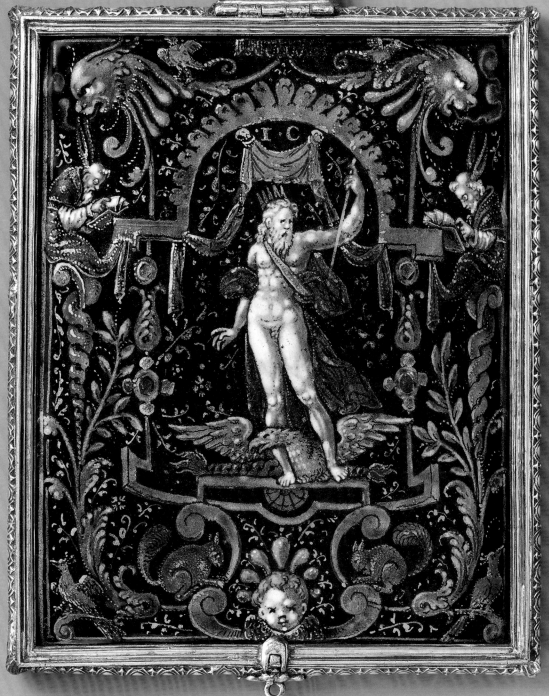

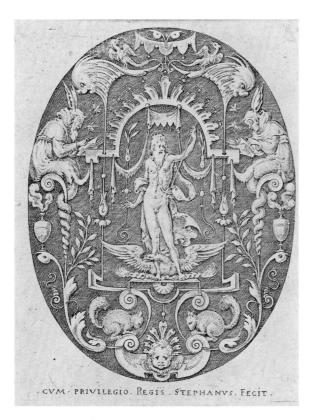

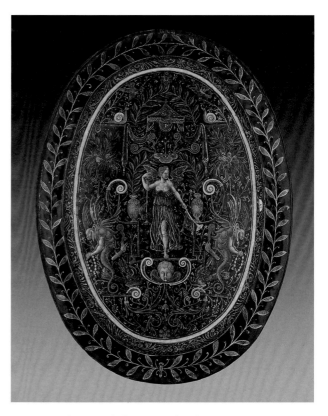

FIG. 2. Etienne Delaune (ca. 1518–1583), *Jupiter under a Canopy (Suite de grotesques avec des divinités)*, before 1559. Engraving, 3⅛ × 2⅜ in. (7.9 × 6 cm). Victoria and Albert Museum, London

FIG. 3. Martial Reymond (d. 1609), Oval Dish: *Apollo and the Muses*; *Fame* (reverse), late 16th century. Painted enamel on copper, partly gilded, 21⁷⁄₁₆ × 16 × 2 in. (54.5 × 40.6 × 5.1 cm). The Frick Collection, New York

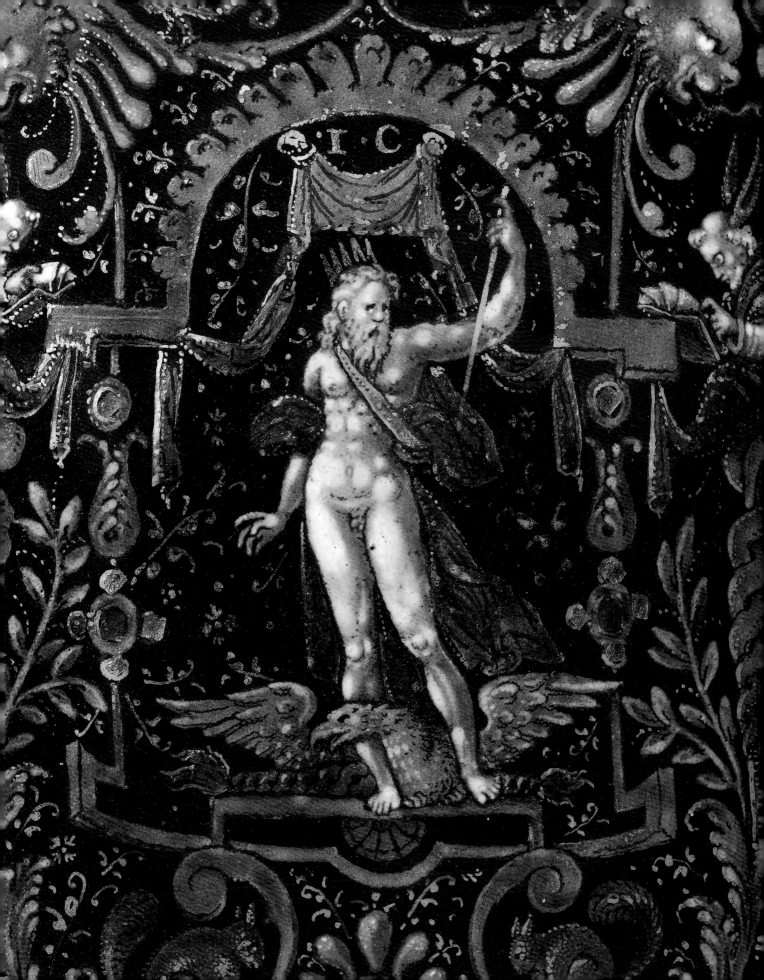

5, 6

ATTRIBUTED TO JEAN DE COURT
(act. 1541–83), ALSO KNOWN AS
MASTER I.C. (act. ca. 1550–85)
AND JEAN COURT DIT VIGIER
(act. ca. 1555–58)

Two Plates: *Jupiter on a Chariot*
and *Saturn on a Chariot*
Limoges, mid-16th century

Enamel on copper, parcel-gilt
DIAM. 9 in. (23 cm) each

Provenance: Alain Moatti, Paris; purchased by
Alexis Gregory, date unknown.

The scenes on these two plates may derive from a series of woodcuts illustrating planetary gods by Gabriele Giolito de' Ferrara (ca. 1508–1578), published in 1534 (figs. 4a–b). Another source of inspiration could be a similar series of woodcuts: *The Seven Planets* by Georg Pencz (ca. 1500–1550) (figs. 5a–b). On the first plate, Jupiter (known as Zeus in Greek mythology) is seated on a chariot drawn by two peacocks. His name (IVPITER) is inscribed on the chariot. Jupiter holds two of his attributes: in his right hand, a thunderbolt, and in his left, a scepter. The composition is set against a dark sky highlighted with gold stars and clouds. Beneath the chariot is a coat of arms that cannot be identified at present. The rim is decorated with four heads of satyrs, grotesques, scrolls, and strapwork. The reverse has two masks with arabesques in gold and strapwork in grisaille.

The second plate has a similar composition. Here, Saturn (known as Kronos in Greek mythology) is seated on a chariot drawn by two dragons. On the chariot is the inscription SATVRNVS. The god holds a sickle in his right hand and a child's foot in his left. Fearing his descendants would overthrow him, Saturn devoured his children. Beneath the chariot is a coat of arms that has not yet been identified. The rim has four masks (mascarons), scrolls, and fruit garlands. The reverse has four masks, strapwork with laurels, and fruit garlands in grisaille and arabesque motifs.

These plates have been attributed to Jean Court dit Vigier, who used the initials I.C.D.V. Several scholars have suggested that the Master I.C., Jean de Court, and Jean Court dit Vigier are, in fact, the same person.[24] A tazza signed and dated ALVMOGES PAR IEHAN DIT VIGIER 1556 (In Limoges,

FIG. 4a. Gabriele Giolito de' Ferrara (ca. 1508–1578), *Jupiter*, 1534. Woodcut, 12³⁄₁₆ × 7½ in. (31 × 19 cm). National Gallery of Art, Washington; Rosenwald Collection

FIG. 4b. Gabriele Giolito de' Ferrara (ca. 1508–1578), *Saturn*, 1534. Woodcut, 12¼ × 7⅜ in. (31.2 × 18.8 cm). National Gallery of Art, Washington; Rosenwald Collection

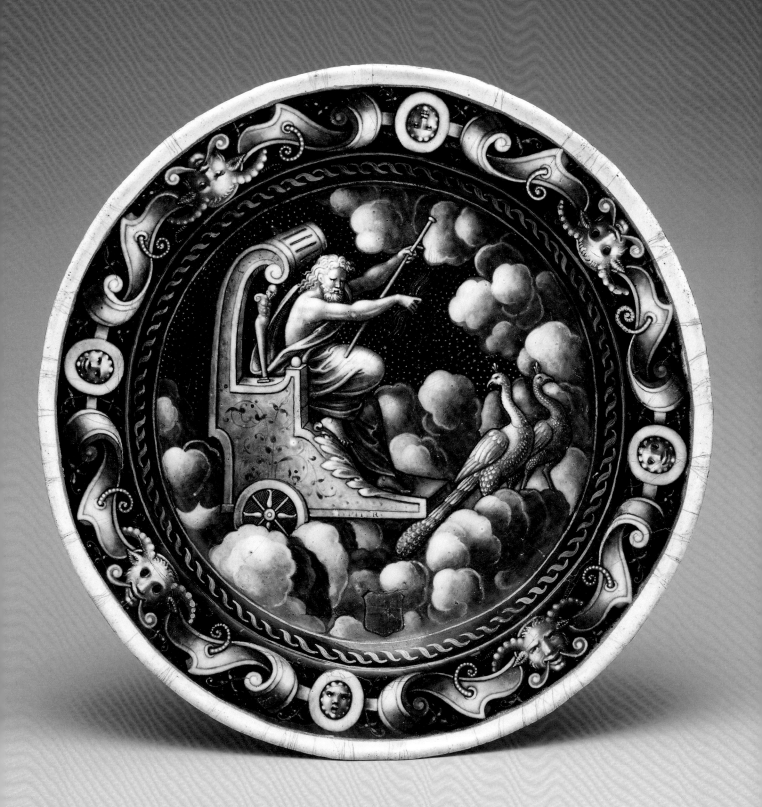

FIG. 5a. Georg Pencz (ca. 1500–1550), *The Seven Planets (Jupiter),* 1530–50. Woodcut, 12¼ × 9½ in. (31.2 × 23.9 cm). British Museum, London

FIG. 5b. Georg Pencz (ca. 1500–1550), *The Seven Planets (Saturn),* 1530–50. Woodcut, 14¼ × 9¾ in. (36.4 × 24.7 cm). British Museum, London

made by Jean dit Vigier in 1556) and intended for Mary, Queen of Scots (r. 1542–67), is in the collection of the Bibliothèque Nationale de France in Paris.[25] Similar plates can be found in collections in Europe and the United States. A plate from the same series in the Walters Art Museum in Baltimore representing the Sun (SOL, known as Helios in Greek mythology) after an engraving by Aeneas Vico (1523–1567) is attributed to Jean de Court,[26] and a plate at the Victoria and Albert Museum with the same subject is attributed to Jean Court dit Vigier.[27] However, a plate with Venus (Aphrodite in Greek mythology) at the Musée du Louvre, previously attributed to the Master I.C./I.C.D.V., is now believed to be by Pierre Courteys (ca. 1520–ca. 1586) based on the style of the reverse of the dish.[28]

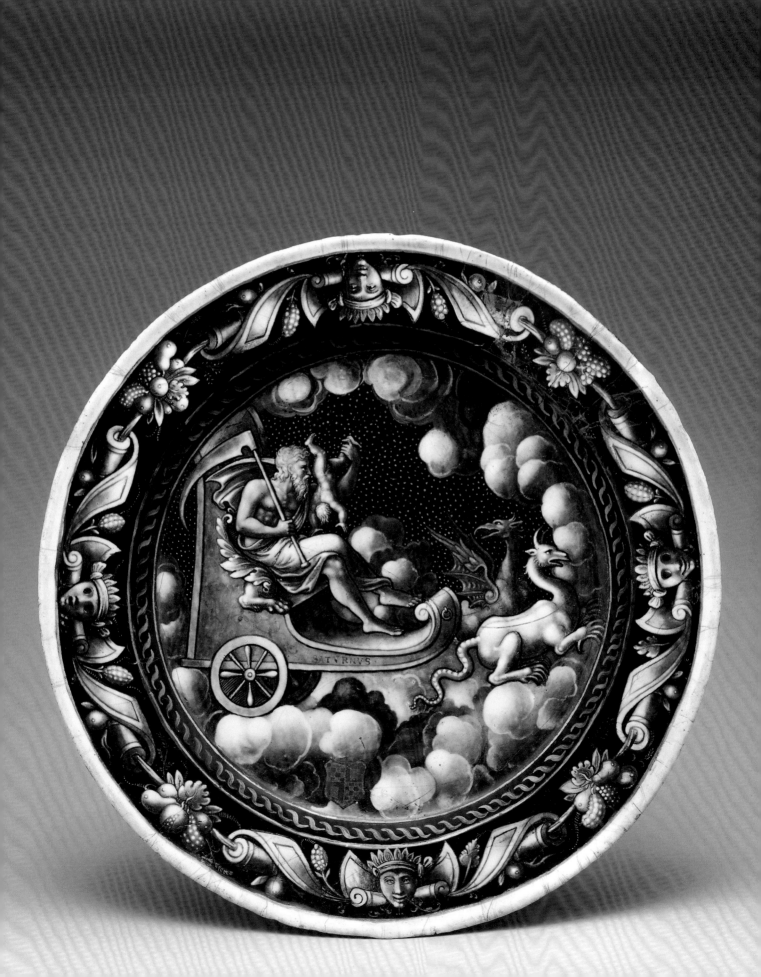

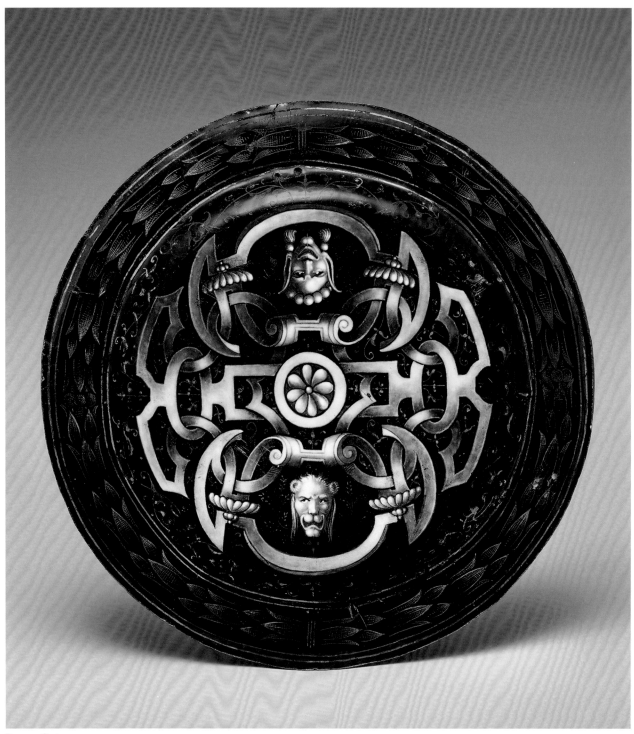

Reverse of cat. 5

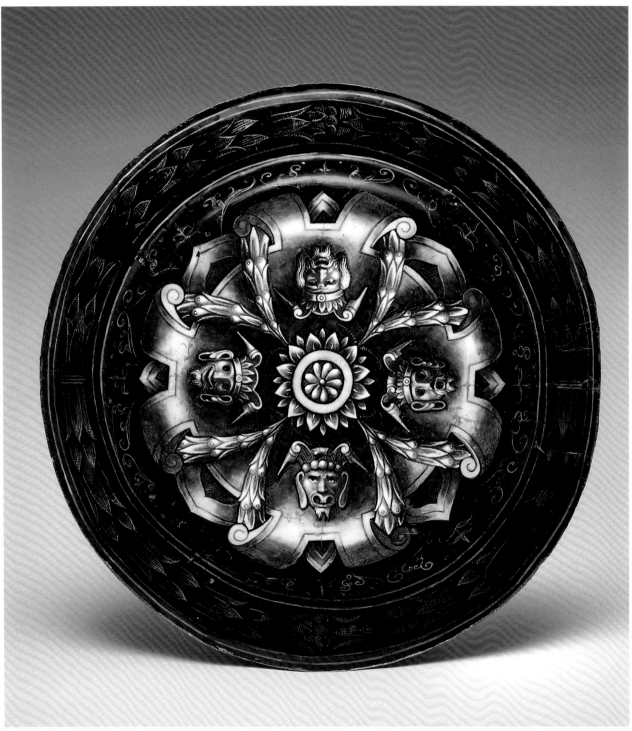

Reverse of cat. 6

7, 8

WORKSHOP OF PIERRE
REYMOND (1513–after 1584)
Two Dishes: *Jason Confronting the
Giants* and *Jason Confronting the
Dragon Guarding the Golden Fleece*
Limoges, mid-16th century

Enamel on copper and parcel-gilt
DIAM. 8 in. (20.3 cm) each

Provenance: Robert Strauss; Cyril Humphris
S.A., London; Cyril Humphris Collection sale,
Sotheby's, New York, January 11, 1995 (lot 147);
Richard Feigen Gallery, New York; purchased by
Alexis Gregory, 1995.

The visual source for this dish decorated in grisaille, with highlighted flesh tones, is *Le Livre de la Conqueste de la Toison d'or par le Prince Iason de Tessalie: Faict par figures avec exposition d'icelles* [sic] (Book of the Conquest of the Golden Fleece, by Prince Jason of Tessalie: Made by Figures with Exposition of Them), a 1563 volume that recounts Jason's quest for the Golden Fleece. Published in French and Latin, the book was an inexhaustible source of inspiration for enamelers in Limoges, among them, Pierre Reymond. The first of these two dishes, numbered 11 in a series of twenty-six, depicts several men fighting with swords in a fierce battle. Jason is completing one of his many assignments to obtain the Golden Fleece: sowing the teeth of Cadmus's dragon. When the sown teeth transform into an army of giant warriors, Jason—shown in the background lifting a rock—follows the advice of Medea, his lover, by picking up a rock and throwing it into the group of giants. Unaware that the rock was thrown by someone outside of their group, the giants begin to attack each other. On the second dish, numbered 12, Jason fights the dragon, guarding the Golden Fleece with a sword in an open landscape with trees, with several figures in the background—the Argonauts—looking at him. The rims of the dishes are decorated with interlinked scrolls and chariots interspersed with satyrs and putti.

Both compositions are taken from engravings by René Boyvin (ca. 1525–ca. 1625) after Léonard Thiry (ca. 1500–1550) (figs. 6a–b).[29] Each scene is framed by an ornate border inspired by models by Rosso Fiorentino (1494–1540) in the gallery of Francis I of France (r. 1515–47) at Fontainebleau. Jehan (Jean) de Mauregard, an officer of the Crown (*greffier des Prévosté et soubaillie de Poissy*), and Jacques de Gohory (1520–1576) commissioned illustrations from Boyvin and dedicated the book to Charles IX of France (r. 1560–74).[30] The figure of Jason, associated with the

FIG. 6a. René Boyvin (ca. 1525–ca. 1625) after Léonard Thiry (ca. 1500–1550), *Jason Throws a Rock at the Giants*, 1563. Engraving, 6¼ × 9¼ in. (15.8 × 23.5 cm). Metropolitan Museum of Art, New York; Bequest of Herbert Mitchell, 2008

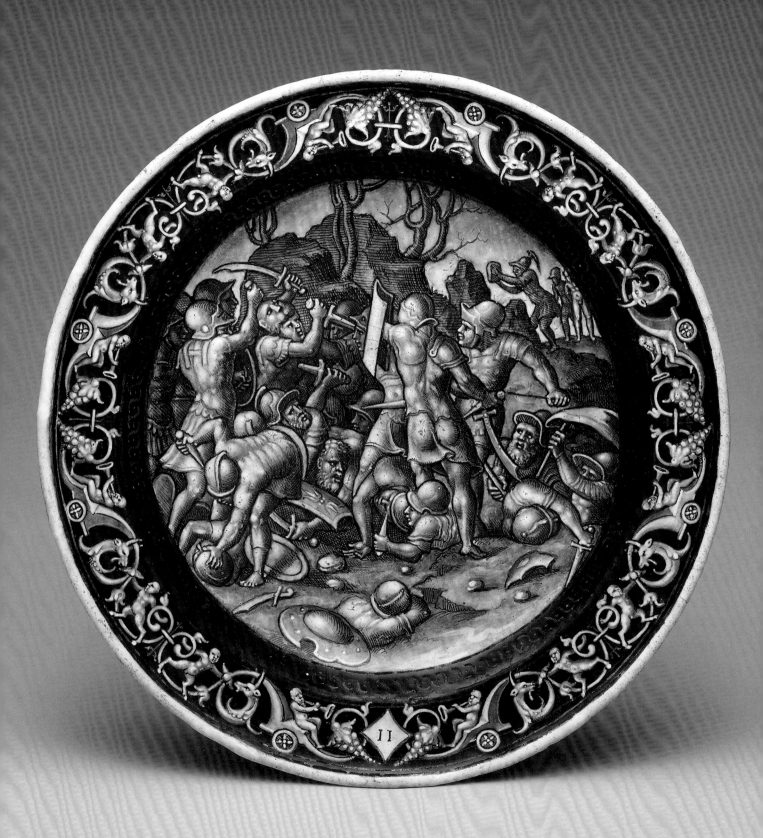

fight against evil, is also closely related to the monarchy and Crusades.[31] Philip III ("the Good"), Duke of Burgundy (1396–1467), for example, chose Jason as a model for the Order of the Golden Fleece, an order of chivalry he created in 1430.

The reverse of each dish is also decorated. On dish number 11 are several masks, strapwork, and two female figures holding baskets of fruit on their heads. The coat of arms shown belongs to the Comte d'Avaux and the Marquis de Roissi. On dish number 12, several putti are surrounded by garlands of fruit. The arms of the Mesmes de Ravignon family impaled with the arms of the Dolu family is flanked by allegories of Air and Earth. The Mesmes later acquired the titles of Comte d'Avaux and Marquis de Roissi. This dish was part of a larger service of twenty-six dishes made by Pierre Reymond in 1567–68.[32] It was probably intended for Jean-Jacques de Mesmes (b. 1532),[33] president of the Grand Conseil, and his wife, Geneviève Dolu (m. 1554), daughter of Jean Dolu, secretary to the king. However, the coat of arms on the reverse of the dish raises several questions. The arms of the Mesmes family do not have a lambel, one of the most common types of *brisure*, which is a mark of cadency often used to distinguish the youngest son or branch of the family from the eldest.[34] As the second son of the family, Jean-Jacques de Mesmes should have broken the coat of arms to distinguish himself from Henri de Mesmes (1531–1596), the first-born son. It is not known if Reymond knowingly painted the coat of arms without a lambel or if another member of the family commissioned the service to celebrate an event that included Geneviève Dolu.[35] Over time, cadency marks such as lambels were used less and less frequently, which is the more likely explanation for their absence on the coats of arms here. Several dishes are in private and public collections, among them, the Musée du Louvre, the British Museum, and the Ashmolean Museum.

FIG. 6b. René Boyvin (ca. 1525–ca. 1625) after Léonard Thiry (ca. 1500–1550), *Jason Confronts the Dragon*, 1563. Engraving, 6¼ × 9⅛ in. (15.8 × 23.2 cm). Metropolitan Museum of Art, New York; Bequest of Phyllis Massar, 2011

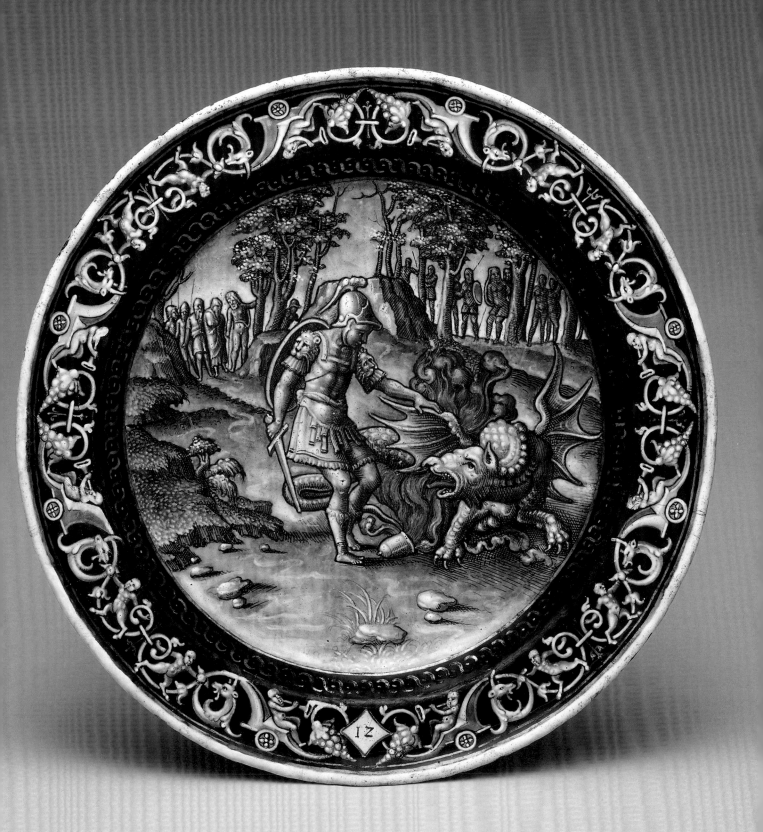

Reverse of cat. 7

Reverse of cat. 8

9

PIERRE REYMOND (1513–after 1584)
Plaque: *The Litanies of the Blessed Virgin*
Limoges, mid-16th century

Enamel on copper, parcel-gilt
H. 7¾ in. (19.7 cm), w. 7½ in. (19 cm),
D. ¾ in. (46.5 cm)
Marks, reverse of plaque: *P.R.*

Provenance: Private collection, Buenos Aires; sale,
Sotheby's, New York, January 26, 2000 (lot 39);
Kugel Gallery, Paris; Jan Dirven Gallery, Antwerp;
purchased by Alexis Gregory, 2001.

Painted in grisaille, this heart-shaped plaque depicts the Litanies of the Blessed Virgin, prayers consisting of a series of supplications, a subject that became popular around 1500 but was not often represented in the enameled production in Limoges at the time. The design of the present composition is based on an engraving by Thielman Kerver (act. 1497–1522), published in a book of hours (*Heures de la Vierge à l'usage de Rome*) in 1505, and is one of the first representations of the Immaculate Conception (Tota Pulchra Es).[36]

Under a dark blue background filled with stars, the Virgin Mary is here dressed in white, her hands joined in prayer. She is positioned within a thin gold mandorla and surrounded by Litanies. Above her, God—also represented within a thin gold mandorla—is blessing her. He is wearing a miter and holding an orb. The Litanies often contained the titles commonly used to describe the Virgin. Numerous symbols associated with the iconography of the Virgin are represented in this composition: a starfish (STELA MARIS) and moon (PVLCRA VT LVNA); trees—a cedar of Lebanon (CEDRVS EXCELTATA) and an olive tree (OLIVASPECIOSA); flowers—lilies among thorns (SICVT LILIV INTER SPINA [sic]) and roses (PLANTACIO ROSE); a garden (ORTVS DOMINE [sic]); a fountain (FONS ORTORY); a spring of water (AQVARVM VIVENCIVM); and a flawless mirror (SPECVLVM SINE MACVLA); as well as architectural elements such as the Tower of David (TVRIS DAVID CVM), Heaven's Gate (PORTA CELI [sic]), and the City of God (CIVITAS DEI). She is blessed by the figure of God represented above her with these words from the Canticle of Canticles (Song of Solomon 4:7): TOTA PVLCRA EST AMICA MEA ET MACVLA NON EST IN TE (Thou art all fair, my love, there is no spot in thee).

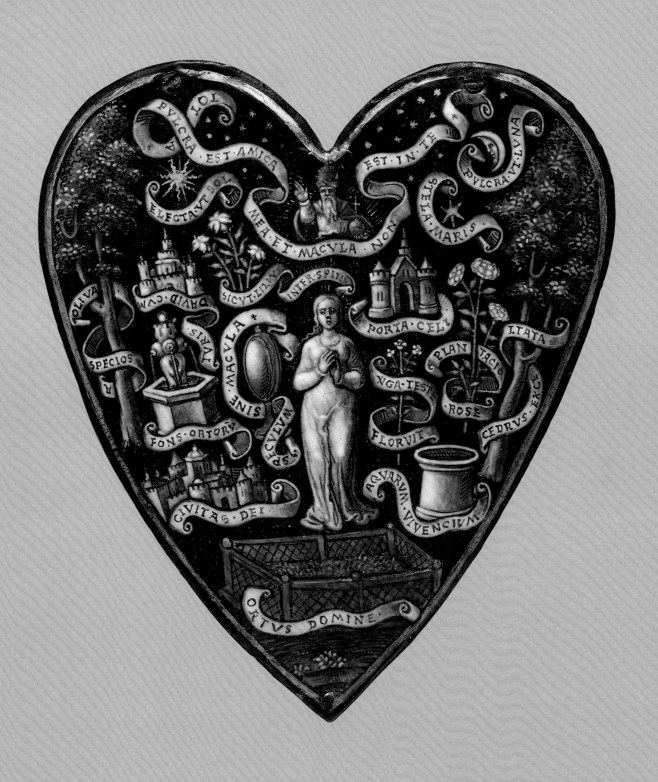

10

CIRCLE OF PIERRE REYMOND
(1513–after 1584)
Saltcellar
Limoges, mid-16th century

Enamel on copper, parcel-gilt
H. 4½ in. (11.5 cm), D. 3⅞ in. (10 cm)

Provenance: Hollingworth Magniac (1786–1867), in what is known as the Colworth Collection, Bedfordshire, England; probably to his son Charles Magniac (1827–1891); sale, Christie's, Manson & Woods, London, July 5, 1892 (lot 240); possibly with the Durlacher Brothers, London; sale, Sotheby's, New York, January 26, 2000 (lot 40); purchased by Alexis Gregory, 2000?

Heresy and faith were important subjects for French enamelers.[37] The main scene on the foot of this saltcellar in baluster form is from the story of Lot from the Old Testament (Genesis 19:1–38). After the destruction of Sodom and Gomorrah, Lot—whose wife was turned into a pillar of salt when, against God's orders, she turned to see the destruction of the city—and his daughters find shelter in Zoar, before settling in a cave in the mountains. During two consecutive nights, his daughters inebriate him and violate him without his knowledge in order to preserve their family line.

The baluster is decorated with four medallions that depict male and female profiles in the antique style. At the top are sea monsters. The receptacle depicts a bearded man in profile crowned with laurels against a dark background with gold dots. The rim is composed of leonine masks and fruit bouquets in strapwork. The main composition is derived from woodcuts by Bernard Salomon (ca. 1508 or 1510–ca. 1561) published in *Les Quadrins historiques de la Bible*. Written by Claude Paradin (ca. 1510?–1573), the book was first published in 1553 by Jean de Tournes (1504–1564). The story of Lot was represented several times by workshops. Lot and his daughters appear in one of the fourteen scenes on a casket from the mid-sixteenth century attributed to the workshop of Pierre Reymond in the Frick's collection (fig. 7).[38] Reymond also represented the subject on two cups made about 1554 and 1555, respectively—at the Musée du Louvre[39] and Musée National de la Renaissance at Château d'Ecouen[40]—while the Master I.C., probably Jean de Court (act. 1541–83), treated the same subject on a cup at the Louvre[41] and in the Frick's collection (fig. 8).[42] A similar composition is on a saltcellar attributed to Pierre Courteys.[43]

FIG. 7. Attributed to the workshop of Pierre Reymond (1513–after 1584), Casket: *Old Testament Subjects* (detail), mid-16th century with later additions. Painted enamel on copper, partly gilded and gilt brass, 4½ × 6½ × 4½ in. (11.4 × 16.5 × 11.4 cm). The Frick Collection, New York

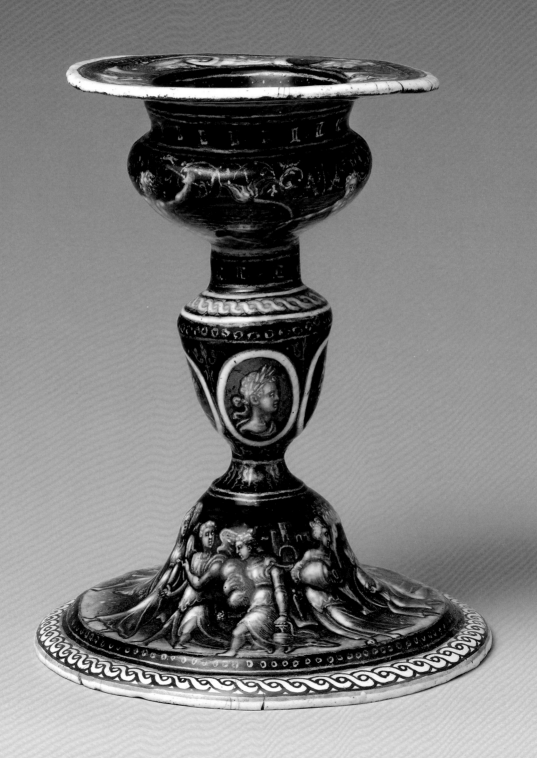

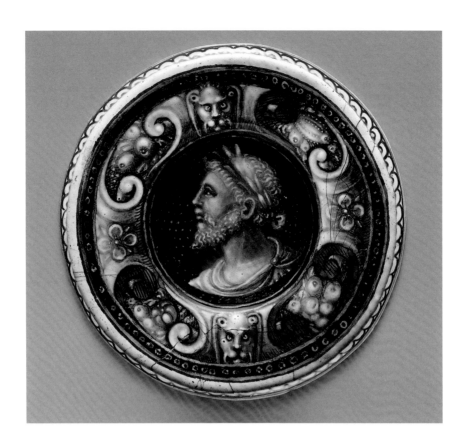

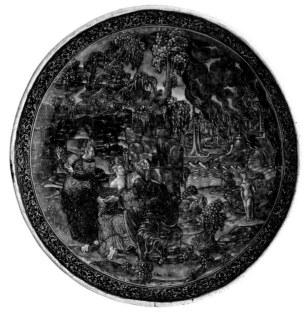

FIG. 8. Master I.C. (act. 1550–85), Cup: *Lot and His Daughters*, late 16th century. Painted enamel on copper, partly gilded, h. 4⅜ in. (11.1 cm), diam. 9⅞ in. (25.1 cm). The Frick Collection, New York

II

FRENCH

Plaque: *Agony in the Garden of Gethsemane*

Limoges, mid-16th century

Enamel on copper, parcel-gilt
H. 4½ in. (11.5 cm), w. 3½ in. (9 cm)

Provenance: Julius Böhler Gallery, Munich; Blumka Gallery, New York; purchased by Alexis Gregory, 2006.

The Limoges workshop that made this plaque is not known. One of the most important events preceding the Crucifixion, the agony of Christ in the garden of Gethsemane is recounted in the four canonical Gospels, although only Mark (14:32–72) and Matthew (26:36–46) mention the precise location of Gethsemane. On this plaque, the apostles Peter, John, and James are resting against rocks with Christ praying in the background. Prefiguring Christ's sacrifice on the cross, an angel in the sky presents a chalice and host in his hands. In the distance, behind the trees, Judas arrives with soldiers. The scene is likely based on a series of fourteen engravings on the Passion of Christ by Lucas van Leyden (ca. 1494–1533), published in 1521 (fig. 9). The plaque composition is very similar to Van Leyden's depiction of the Agony in the Garden. The Passion of Christ was a popular subject among enamelers in Limoges. The Agony in the Garden was depicted by Jean Pénicaud I (ca. 1490–after 1543), about 1520–25, after an engraving by Martin Schongauer (ca. 1450/53–1491) (fig. 10).[44]

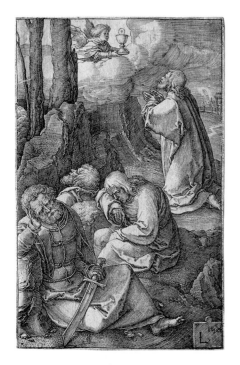

FIG. 9. Lucas van Leyden (ca. 1494–1533), *The Agony in the Garden*, 1521. Engraving, 4½ × 2¹⁵/₁₆ in. (11.5 × 7.5 cm). Cleveland Museum of Art; Dudley P. Allen Fund

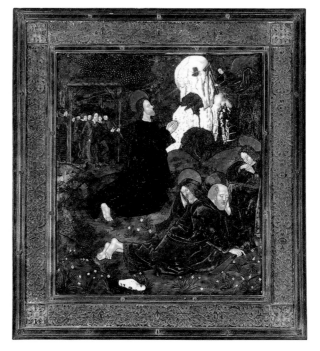

FIG. 10. Jean Pénicaud I (ca. 1490–after 1543), *The Agony in the Garden*, ca. 1520–25. Painted enamel on copper, partly gilded, 10⅞ × 9½ in. (27.6 × 24.1 cm). The Frick Collection, New York

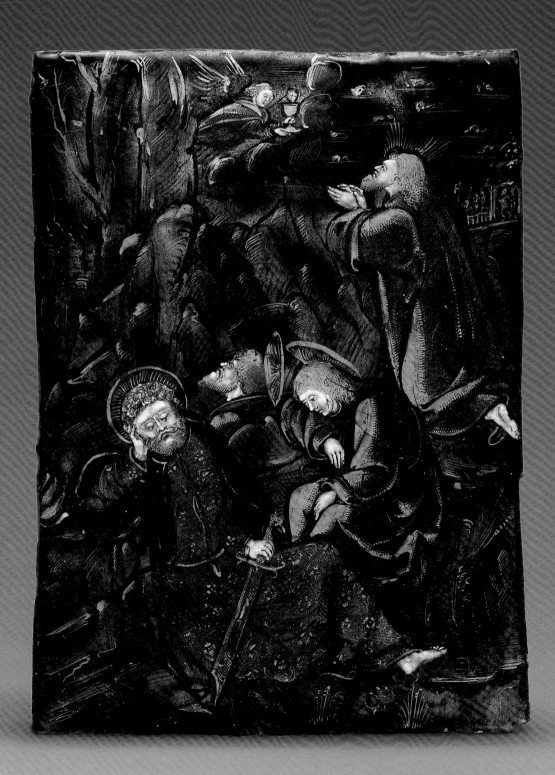

12

ATTRIBUTED TO MARTIAL
COURTEYS (ca. 1550–1592)
Calendar Plate for May
Limoges, ca. 1565–75

Enamel on copper and parcel-gilt
DIAM. 7¼ in. (18.5 cm)

Provenance: Sale, Christie's, New York, September
26, 2001 (lot 257); Bernard Descheemaeker Gallery,
Antwerp; purchased by Alexis Gregory, 2002.

Scenes from the Labors of the Months—a series depicting scenes for each month of the year paired with a zodiac sign—were extremely popular with French enamelers and their workshops. Here, the month of May is represented with music in a composition derived from an engraving by Etienne Delaune (ca. 1518–1583) published in 1561 as part of his first series of Labors of the Months (fig. 11); he published a second series in 1568. Painted in grisaille, the main composition centers on two women attentively looking at a book, accompanied by two children and a man—crowned with laurels—who read a book with a score. A second man, holding a lute, pats one of the children on the head. A castle-like structure and gardens appear in the background, along with several trees and a fountain. Farther away, hills and a mill with a waterwheel can be seen. The rim is decorated with strapwork, musical instruments (lyres, lutes), and music books. Two cartouches at the top and bottom include the Roman numeral II and MAYVS (May), respectively.

At the center of the reverse of the plate are two putti—twins—playing on the grass beneath a sky filled with gold stars, representing the Gemini zodiac sign. The scene is surrounded by strapwork with a putto's head at the top and another at the bottom. The outer rim is composed of a succession of oval cabochons and faceted rectangles.

The subject and the style can be compared to works by Martial Courteys and his workshop. Little is known about Courteys. He belonged to a family of enamelers and signed his works with the initials M.C. His father was Pierre Courteys (ca. 1520–ca. 1586), and one of his brothers was also an enameler. Few of his works survive; a complete series of the Labors of the Months by Courteys is in the collection of the Los Angeles County Museum of Art.[45]

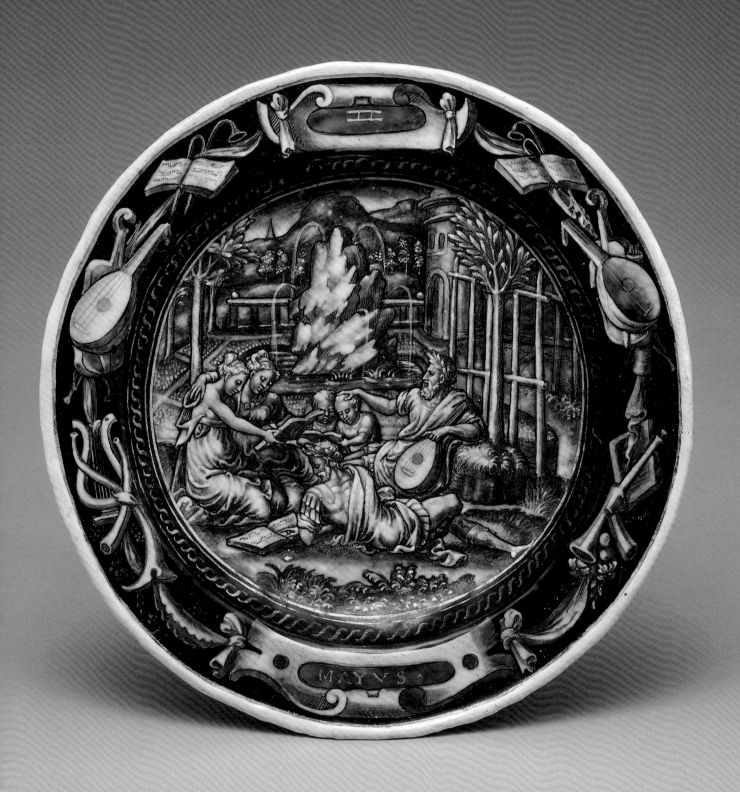

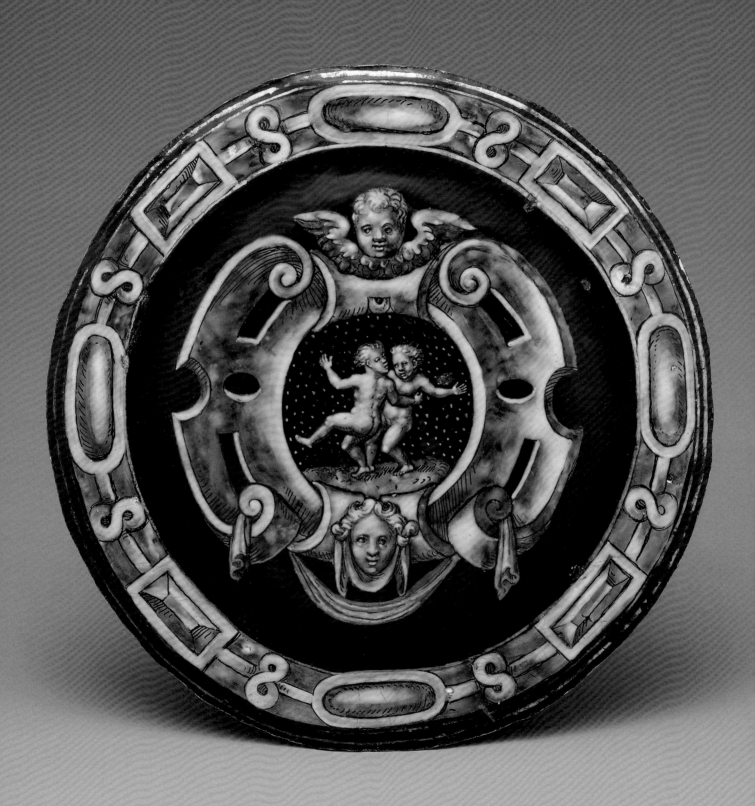

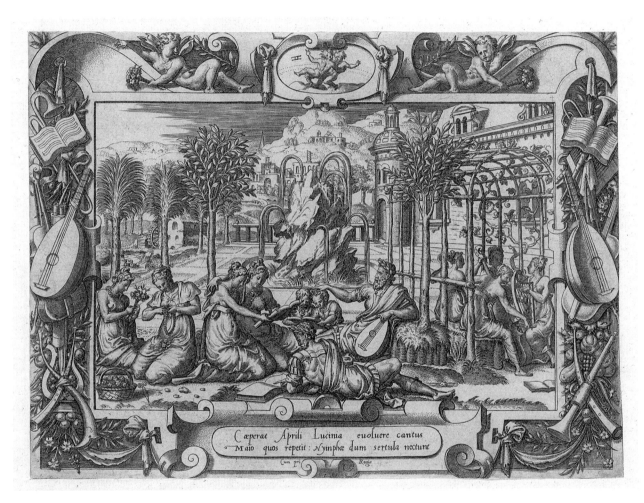

FIG. 11. Etienne Delaune (ca. 1519–1583/95),
The Labors of the Months: May, ca. 1561–1572?.
Engraving, 6⅞ × 9⅜ in. (17.5 × 23.7 cm).
Folger Shakespeare Library, Washington, DC

13, 14

WORKSHOP OF PIERRE
REYMOND (1513–after 1584)
Pair of Covered Tazzas
Limoges, ca. 1566

Enamel on copper, parcel-gilt
H. 8½ in. (21.6 cm), DIAM. 7¼ in. (18.5 cm) each
Marks, inside the bowl: *P.R.*

Provenance: Baron Carl Mayer de Rothschild
(1818–1874), Mentmore Towers, Mentmore,
Buckinghamshire; by descent to Hannah de
Rothschild (1851–1890) and Archibald Philip
Primrose, 5th Earl of Rosebery (1847–1929),
Mentmore Towers, Mentmore, Buckinghamshire;
by descent to the Earls of Rosebery, Mentmore
Towers, Mentmore, Buckinghamshire; sale,
Sotheby Parke Bernet & Co., Mentmore Towers,
on behalf of the executors of the 6th Earl of
Rosebery, May 18–23, 1977 (lot 1125); sale, Sotheby's,
New York, November 27, 1981 (lot 56); sale,
Sotheby's, New York, May 31, 1986 (lots 167, 168);
Alain Moatti, Paris; purchased by Alexis Gregory,
date unknown.

These tazzas are part of a larger service with arms attributed by most scholars to Pierre Séguier (1504–1580), principal magistrate of the *parlement* of Paris (*president à mortier*)—one of the most important legal offices during the ancien régime—or to one of his relatives. Although the coats of arms represented are similar to those of the Séguier family, several elements differ—three stars instead of two, and a *chef cousu de gueules* (red band on top)—and could suggest another patron, perhaps the Chabriant de Cornac family, who lived about forty-five miles from Limoges.[46] Included in the service were these two tazzas with lids depicting subjects from the Old Testament. The first tazza, inscribed with *Exodus XVI*, depicts the Fall of Manna (Exodus 16:1–36), in which bread and a flock of quails miraculously fall from heaven when the Israelites, in the desert following their escape from Egypt, complain to Moses and Aaron about their lack of food. The scene on the tazza's lid shows figures near tents collecting the fallen food in baskets, while Moses points to the miracle with his golden staff. The decoration inside the lid includes acanthus leaves, arabesques inspired by Jacques Androuet du Cerceau (1510–1584), and four framed scenes drawing on mythological subjects. The figure seated on a bull references the abduction of Europa by Jupiter in Ovid's *Metamorphoses*, and the figure surrounded by sea creatures probably evokes the jealous Circe transforming her rival, Scylla, into a monster. The other two framed scenes are not clearly identified. The interior of the cup depicts a scene from Exodus 18:13–17: people inquiring about the laws of God surround an enthroned Moses. His father-in-law, Jethro, advises him to select honorable men to relieve him of his burden as the only judge. Two different scenes are illustrated on the foot: the procession of Amphitrite and Neptune after their union, and an episode from Exodus 17:6, in which Moses strikes a rock that miraculously begins to spout water.

The second tazza is similarly decorated. The exterior of the lid illustrates a scene identified as *II Rois XVIII* (2 Samuel 18:9–14). Absalom, a son of King David who rebelled against him, is riding a mule when he encounters David's men. As Absalom rides under a tree, his hair gets caught in the branches, and this causes him to be detected by David's men. Against David's wishes, Joab—the king's commander—thrusts three darts in Absalom's heart, killing him instantly. Like the previous tazza, the interior of the lid is adorned with acanthus leaves, laurels, and arabesques. In place of the first tazza's four mythological scenes are four framed winged putti. The subject of the death of Absalom was also used by Reymond and his workshop on a candlestick made in 1564.[47] The interior of the cup—which includes the words *III Rois X* (1 Kings 10)—depicts the Queen of Sheba in Jerusalem. After learning of King Solomon's relationship with God, she travels to personally question him about it. The scene shown captures the moment of her arrival when she kneels before Solomon. On the foot is a scene from 2 Kings 17:24–25, in which the king of Assyria brings people from Babylon to replace the Israelites in Samaria, but because they do not

fear God and follow his laws, God sends lions among them, and some of them are killed.

The iconography on the tazzas derives from woodcuts by Bernard Salomon (ca. 1508 or 1510–ca. 1561) created as illustrations for *Les Quadrins historiques de la Bible*, a book by Claude Paradin (ca. 1510?–1573) first published in 1553 by Jean de Tournes (1504–1564). The scenes were sometimes altered or simplified to fit the form of the object, which is the case for the scene from Exodus 17:6, where fewer figures are represented in the enameled composition. The background—trees, mountains, tents, and the figure of God in the sky, who is the source of the miracle—is omitted (fig. 12). As shown in these tazzas, Christian themes often coexisted with mythological scenes and motifs in enamel production of the period.[48] The Old Testament became increasingly popular, and enamelers used it as one of their principal sources. Scholars have identified as recurrent themes the covenants between God and his people (Noah's ark, Joseph, Moses, the golden calf) and figures known for their sense of justice—often biblical kings, such as David, Solomon, and Josiah—who had to resolve conflicts in order to restore peace.[49] This echoed the religious conflicts between Catholics and Huguenots in France. Many people believed that Charles IX of France (1550–1574) would bring harmony back to the realm.[50]

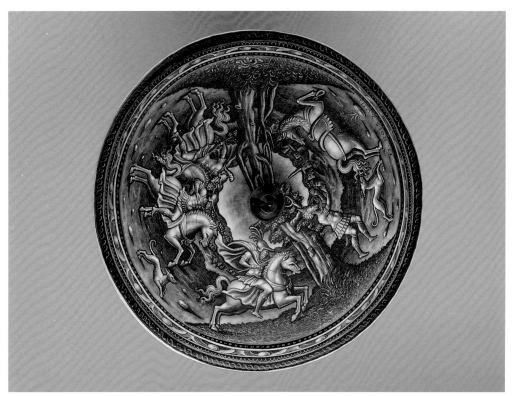

Top of cat. 13

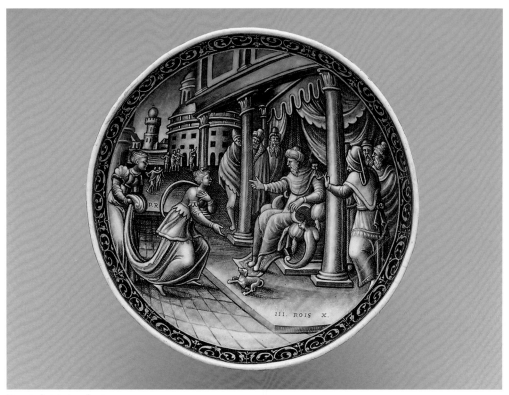

Receptacle interior of cat. 13

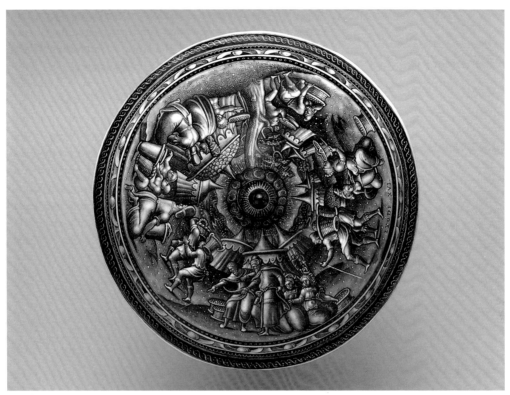

Top of cat. 14

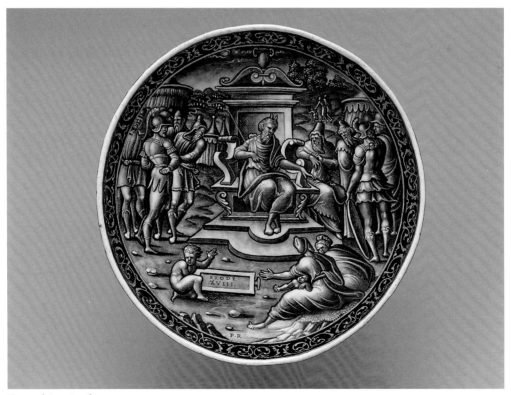

Receptacle interior of cat. 14

15

PROBABLY SOUTH GERMAN
Seated Lion Pomander
ca. 1575

Gold, diamond, rubies, and enamel
H. 5 in. (12.7 cm), W. 3½ in. (9 cm), D. 3½ in. (9 cm)

Provenance: Crown Jewels of Portugal, Lisbon;
inherited by Nevada Stoody Hayes (1870–1941),
Princess of Braganza, widow of Prince Afonso,
Duke of Oporto (1865–1920), 1920; Warren J. Piper
(1891–1948), Chicago; his sale, 1949–50?; Thomas F.
Flannery Jr. (1926–1980), Chicago; his sale, Sotheby
Parke Bernet & Co., London, December 2, 1983
(lot 291); sale, Sotheby's, London, July 6, 1995 (lot
214); purchased by Alexis Gregory, date unknown.

Cast in gold and made of six distinctive parts—body, tail, head, collar, crown, and heart—this seated lion has a pelt and a flowing mane richly mounted with cut and faceted diamonds and rubies. The head and collar are set with rubies, diamonds, and black enamel. The chasing creates the effect of fur. The lion clutches a gold heart with diamonds, which bears an Italian inscription in dark blue enamel that may be a line from a poem: CHE.GIRE.ANCOR on the front and QU.I.S.OGGI ORNA on the reverse (Here the heart adorns itself today so as to keep beating).[51] The head, which can be unscrewed, and the small holes located on the head—in the nostrils and the mouth—identify this work as a pomander, an object used to hold various herbs, spices, and resins (rosemary, lavender, camphor, cinnamon, cloves, nutmeg, ambergris, civet, and deer musk). Pomanders were often suspended from a long belt, a girdle around the hips/waist, or worn around the neck to diffuse scents. It was also believed that they helped to protect against disease.

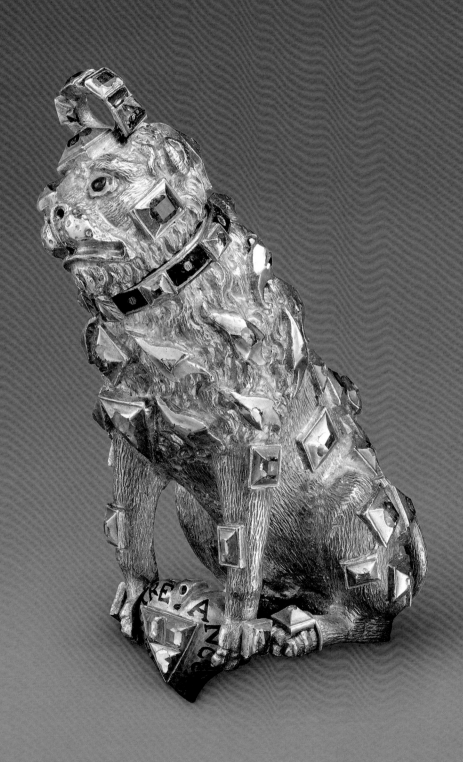

16

FRENCH

Triptych of the Crucifixion and Sibyls
Limoges, 1584

Enamel on copper, parcel-gilt
H. 11¼ in. (28.6 cm), w. 10¾ in. (27.3 cm),
D. ⅞ in. (2.2 cm)

Provenance: Madame Vᵉ Flandin, Paris; A. C. Chapin; H. F. Dawson, New York; sale, Joseph Brummer Art Gallery, New York; sale, Parke Bernet Galleries Inc., New York, April 20–23, 1949 (lot 728); sale, Christie's, New York, January 1, 1993 (lot 79); Jan Dirven Gallery, Antwerp; purchased by Alexis Gregory, 1995.

It is not known who created this triptych.[52] The central panel depicts Christ on a cross between two thieves on Mount Golgotha. The Roman soldier Longinus, on horseback, plunges a spear into his side. On the right are three figures mourning: a kneeling Mary Magdalene and the Virgin supported by St. John. A Franciscan identified by the inscription at the top—FRATER FRANCISCVS / GONZAGA GENERALIS / MINISTER FRA[N] CISCANORV[M] / 1584 (Francesco Gonzaga, general of the Franciscans, 1584)—prays before them. Francesco Gonzaga (1546–1620) was appointed Minister General of the Order in 1579 and served as Bishop of Mantua from 1593 until his death.[53] In the background, four Roman soldiers, three of whom are on horseback, are returning to a fortified city. In the landscape under a starry sky is Jerusalem. The right and left wings of the triptych are divided into panels representing twelve sibyls holding the instruments of the Passion. Each sibyl, or prophetess, is identified by a caption. On the right wing are the Persian, Cimmerian, Libyan, Delphic, Samian, and Cumaean sibyls. On the left wing are the Hellespontine, Phrygian, European, Tiburtine, Agrippine, and Erythraean sibyls. The wings may have been added later to form a triptych, since the association of the Crucifixion and sibyls is unusual in Limoges enamels.[54] One example is an altar formed by twenty-one plaques by Léonard Limosin (ca. 1505–ca. 1575), which is in the Walters Art Museum in Baltimore. These plaques depict prophets, apostles, and sibyls holding instruments of the Passion.[55]

The back of the frame of this triptych is painted. On the central part are Greek letters—alpha and omega—that are written in yellow pigment. The scene represented on the two wings depicts St. Francis receiving the stigmata.

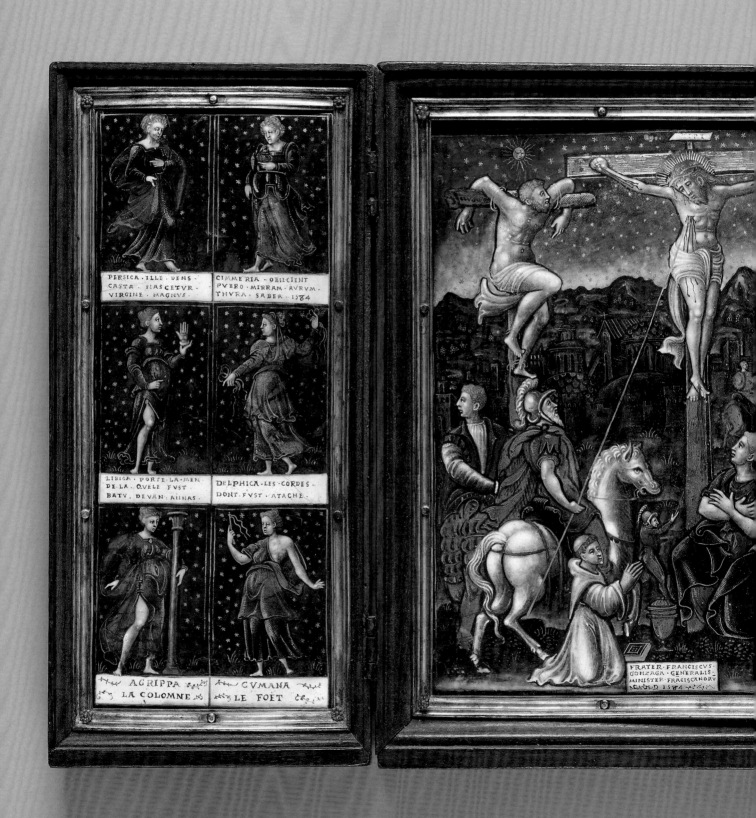

PERSICA · ILLE · DENS · CASTA · NASCETVR · VIRGINE · MAGNVS ·

CIMMERIA · OBIICIENT · PVERO · MIRRAM · AVRVM · THVRA · SABER · 1584

LIBICA · PORTE · LA · MEN DE · LA · QVELE · FVST BATV · DEVAN · AINAS ·

DELPHICA · LES · CORDES DONT · FVST · ATACHE ·

AGRIPPA LA · COLOMNE

CVMANA LE · FOET

FRATER · FRANCISCVS · GONZAGA · GENERALIS · MINISTER · FRACISCANORV ACVND 1584

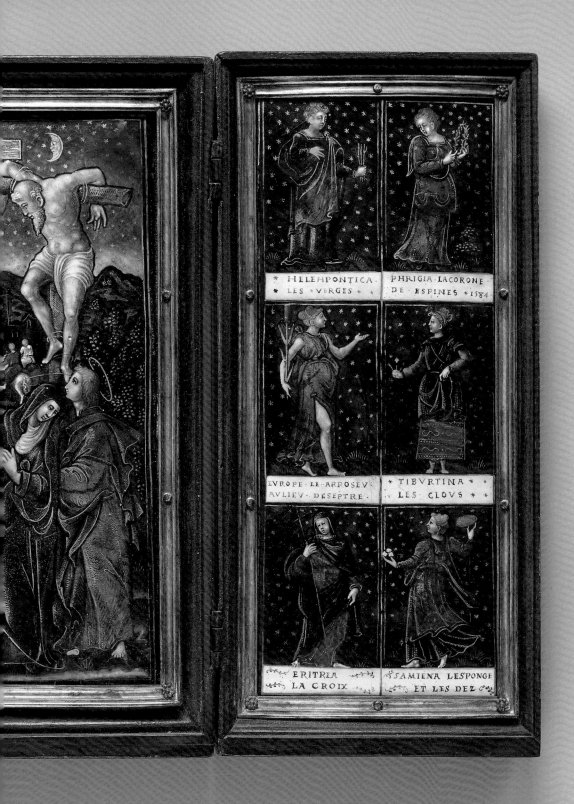

* HELEHPONTICA .
* LES · VERGES *

PHRIGIA · LACORONE
DE · ESPINES * 1584

EVROPE · LE · ARPOSEV ·
AVLIEV · DESEPTRE ·

TIBVRTINA *
LES · CLOVS *

ERITREA
LA · CROIX

SAMIENA · LESPONGE
ET · LES · DEZ

17

PIERRE REYMOND (1513–after 1584)
Ewer
Limoges, late 16th century

Enamel on copper, parcel-gilt
H. (without handle) 8½ in. (21.6 cm)
Marks, spread on either side of join where opening meets handle: *P.R.*

Provenance: Baron Mayer de Rothschild (1818–1874), Mentmore Towers, Mentmore, Buckinghamshire; by descent to Hannah de Rothschild (1851–1890) and Archibald Philip Primrose, 5th Earl of Rosebery (1847–1929), Mentmore Towers, Mentmore, Buckinghamshire; by descent to the Earls of Roseberry, Mentmore Towers, Mentmore, Buckinghamshire; 6th Earl of Rosebery sale, Sotheby Parke Bernet & Co., Mentmore Towers, May 18–23, 1977 (lot 1122); Alain Moatti, Paris; purchased by Alexis Gregory, date unknown.

Pierre Reymond ran a highly successful workshop in Limoges and, together with Léonard Limosin (ca. 1505–ca. 1575), was one of the most prolific enamelers of the sixteenth century. The body, shoulder, handle, spout, and foot of this ewer were probably made separately, then connected with wires or rivets.[56] The handle, spout, and foot are decorated with gold enamel. The interior of the ewer is white opaque enamel, while the exterior is decorated in a dark transparent enamel. On the neck of the ewer are acanthus leaves rising toward the spout, and the shoulder has grotesques. Two chariots facing each other and separated by a mask are driven by naked and winged figures accompanied by a peacock. A figure—probably a satyr—pushes each chariot. The scenes are painted in grisaille. The main scene, on the body of the ewer, is of several men on horseback or on foot engaged in battle—using spears, bows, arrows, and swords—near a military camp. Identified by the gold letters *Exodus XVII* at the top of the register, the scene illustrates the struggle in the Book of Exodus (17:8–16) between Amalek and Joshua in Rephidim after the Israelites were provided with water. Victorious due to Moses's prayers, Joshua is depicted sitting on a hill in the background next to Aaron and Hur, both of whom supported Moses's arms while he was praying.

Subjects depicting violent events from the Bible were popular in the production of Limoges enamels. From Cain killing his brother Abel (Genesis 4:1–16)—represented on a casket attributed to the workshop of Pierre Reymond in the Frick's collection (fig. 13)—to violent scenes showing dismembered body parts,[57] Limoges enamels often reveal "men's inner evil."[58] This is a recurrent theme during a time when conflict between Catholics and Huguenots was raging in France. Scholars have suggested that this violence was often ritualized in order to dehumanize heretics.[59] Huguenots would also objectify violence to demonstrate how corrupt the Catholics were.[60] Limoges remained Catholic mainly because its citizens were hostile to the Huguenots in charge of the region. Tensions arose when Jeanne d'Albret (1528–1572), queen regnant of Navarre between 1555 and 1572 and vicomtesse of Limoges, came to the city in 1564.

Though Reymond's faith is not confirmed, several motifs in his work—often copied after engravings—seem to denounce the corruption and debauchery of the Catholic Church. Monks are sometimes shown with women or satyrs or depicted as monstrous creatures.[61] Despite these religious tensions, many enamelers worked for both prominent Catholic and Huguenot families.

FIG. 13. Attributed to the workshop of Pierre Reymond (1513–after 1584), Casket: *Old Testament Subjects* (detail), mid-16th century with later additions. Painted enamel on copper, partly gilded and gilt brass, 4½ × 6½ × 4½ in. (11.4 × 16.5 × 11.4 cm). The Frick Collection, New York

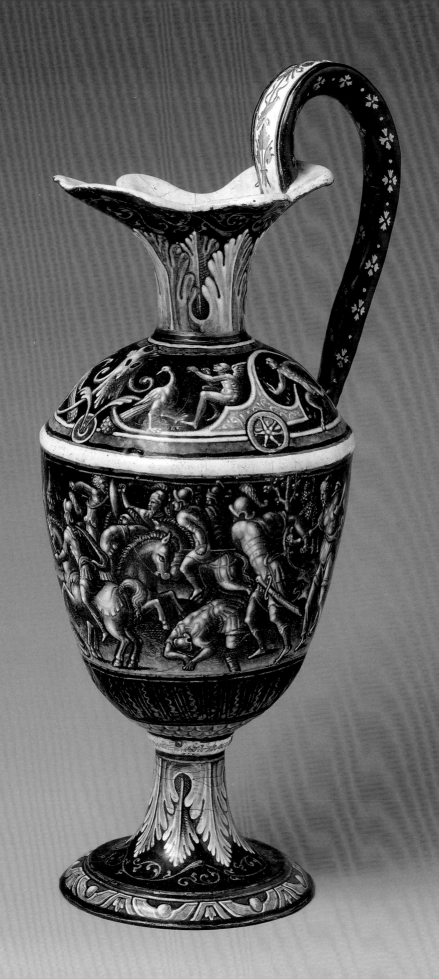

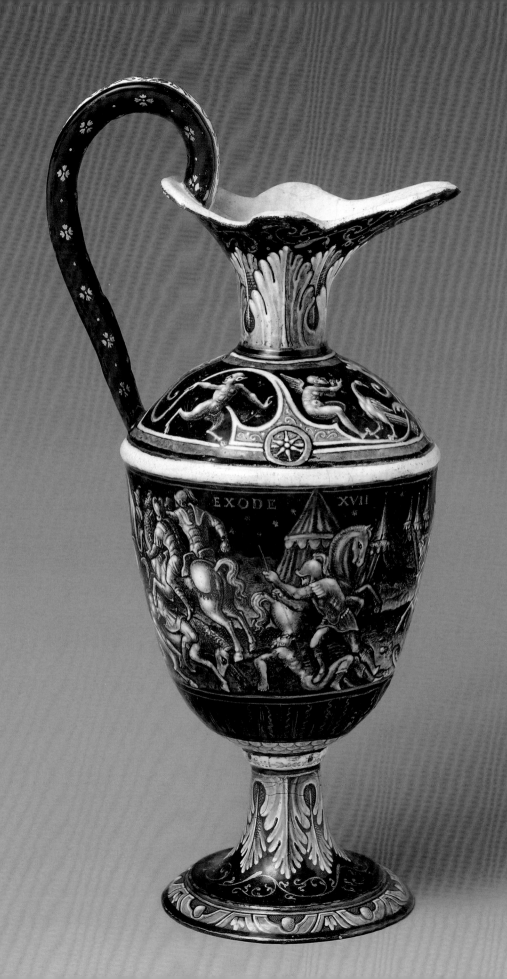

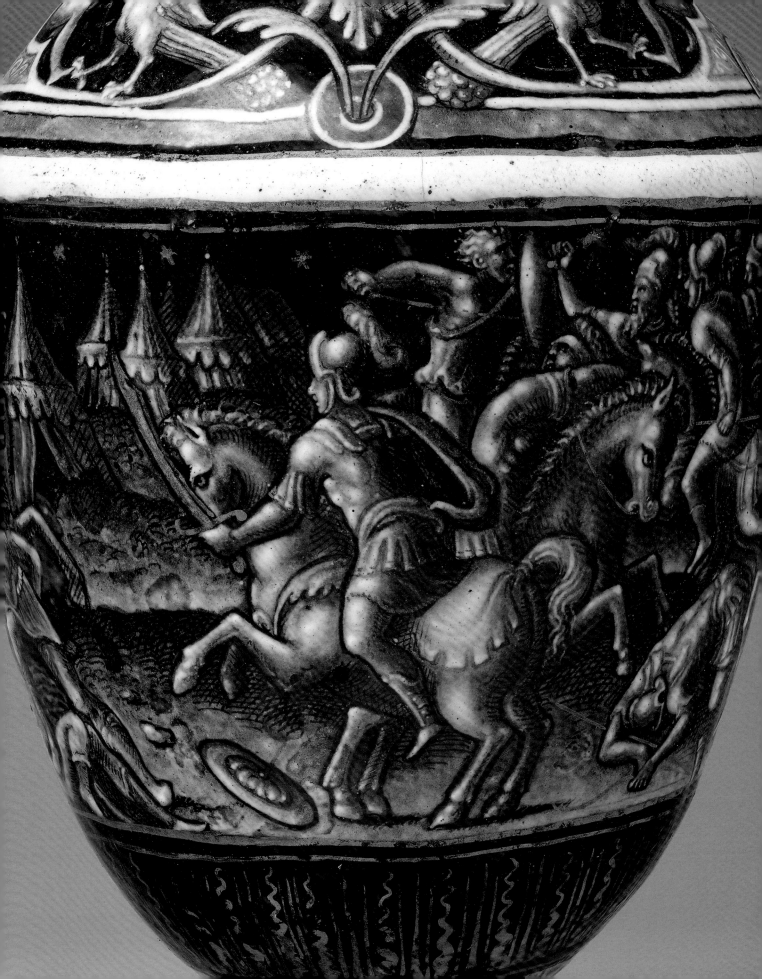

18

SUZANNE DE COURT (act. ca. 1600)
Oval Medallion: *Apollo and
the Muses*
Limoges, ca. 1600

Enamel on copper, parcel-gilt
H. 4¼ in. (11.5 cm), w. 3⅜ in. (8.6 cm)
Marks, at top of plaque: *S.C.*

Provenance: Baron Albert von Goldschmidt-
Rothschild (1879–1941), Frankfurt; sale, Hermann
Ball and Paul Graupe, Berlin, March 14, 1933 (lot
67); sale, Sotheby's, London, April 21, 1988 (lot 362);
private collection, Kapellen, Belgium, until 1995;
Jan Dirven Gallery, Antwerp; purchased by Alexis
Gregory, 2001.

FIG. 14. Giorgio Ghisi (1520–1582) after Luca
Penni (1500/4–1557), *Apollo and the Muses*,
ca. 1557. Engraving, 13 × 16⁵⁄₁₆ in. (33 × 41.5 cm).
The Metropolitan Museum of Art, New York;
The Elisha Whittelsey Collection, The Elisha
Whittelsey Fund, 1949

Suzanne de Court is the only woman known to have run a work-shop in Limoges during the sixteenth and early seventeenth centuries. Unfortunately, nothing is known of her life. The patronymic De Court is often associated with the name Vigier, and archival sources mention the name of a Suzanne Vigier, who married the goldsmith Jean Le Masit and gave birth to a child, Jean, in 1598.[62] At the time, Suzanne was a Huguenot name, which would explain why she does not appear in Catholic baptismal registers in Limoges.[63] Her patronymic and the proximity between the names Vigier and De Court suggest that she may have been a member of the prominent Huguenot family of enamelers. She signed her works either with her initials, S.C., or with the names Suzanne Court, Suzanne de Court, or Suzanne Cour. This inscription was, in rare cases, followed by the letter *f.*, short for *fecit* (made it). It appears, for instance, on two enameled ewers at the Musée du Louvre and the British Museum, respectively, and on an oval dish at the Louvre.[64] The presence of the mark SVSANNE.DE.COVRT.F could suggest that she may have been involved in the production, not only as the head of the workshop but also as an enameler.

This oval medallion represents Apollo and the Muses on Mount Helicon, a popular mythological subject among enamelers.[65] The subject, which combines excerpts from the *Metamorphoses* by Antoninus Liberalis and passages from Pausanias's *Description of Greece*, was used in Fontainebleau's Galerie d'Ulysse, decorated in 1533–35 by Francesco Primaticcio (1504–1570), then by Nicolò dell'Abate (1509/12–1571). The gallery was revised several times before its destruction in 1738–39.[66] In this composition, the god, flanked by a putto and Pegasus, is playing his lyre on grass of a deep green color. Two bearded men wearing laurel wreaths, perhaps poets, are gesturing in his direction. Seated at their feet are the Muses: Erato, the Muse of lyric poetry; Calliope, of epic poetry; Thalia, of comedy and pastoral poetry; Urania, of astronomy; Terpsichore, of dance; Melpomene, of tragedy; Euterpe, of music; Clio, of history; and Polyhymnia, of sacred poetry. The group is separated by a river into which the nymph Castalia pours water from a vase. The Muses are represented with instruments and playing music. At the top of the medallion are the initials S.C. in gold letters. The composition derives from a print by Giorgio Ghisi (1520–1582) that was made after a drawing by Luca Penni (1500/4–1557) (fig. 14). Penni's design—engraved several times, including by Etienne Delaune (ca. 1518–1583)—was inspired by a print by Marcantonio Raimondi (ca. 1470/82–1527/34) that was based on Raphael's *Parnassus* fresco in the Stanza della Segnatura at the Vatican.

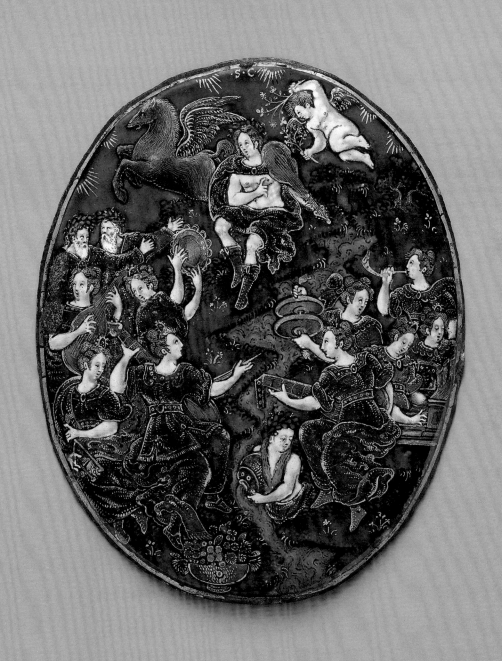

19

POSSIBLY SCHOOL OF
FONTAINEBLEAU
Ewer
Late 16th or early 17th century

Glazed earthenware
H. 8¼ in. (21 cm), w. (without handle) 4¾ in.
(12 cm)

Provenance: Rothschild family (A. de R?);
confiscated by the Einsatzstab Reichsleiter
Rosenberg during the Nazi occupation in
France, ERR (n. R 4141); transferred to Jeu de
Paume, Paris, ERR; transferred to Buxheim,
Germany; transferred to Lager Peter (code name
for Altaussee Salt Mines), Austria; repatriated
in 1946; restituted to Maurice de Rothschild
(1881–1957), 1946; purchased by Alexis Gregory,
date unknown.

This ewer was meant to be displayed and was likely never used. It may have been made by a follower of Bernard Palissy (1509–1590), who was well known for his distinctive lead-glazed earthenware. The so-called School of Fontainebleau refers to the style of the work of an international group of artists led by Italian painters such as Rosso Fiorentino (1494–1540) and Francesco Primaticcio (ca. 1504–1570), and goldsmiths like Benvenuto Cellini (1500–1571), and commissioned by Francis I of France (r. 1515–47) for his residence at Fontainebleau. Their work was an important source of inspiration for ceramists during the sixteenth and seventeenth centuries, and engravings played a key role in the transmission of motifs as most forms such as this were based on metalwork. The cylindrical body of this ewer, composed of two registers, is decorated with acanthus leaves and foliage. These motifs are glazed with yellow, green, and blue. The handle has two scrolls and is decorated with foliage. The foot is set with rosettes. The interior of the ewer is also glazed with green, and the decoration was likely molded. While several scholars have studied the production made after the death of Palissy, as well as the composition (clay and glazes chemistries) of these pieces, we do not know who produced this piece.[67] A similar example was in the Rothschild collection in London.[68] Several post-Palissy wares are in public collections, among them, the Victoria and Albert Museum[69] and the Musée du Louvre.[70]

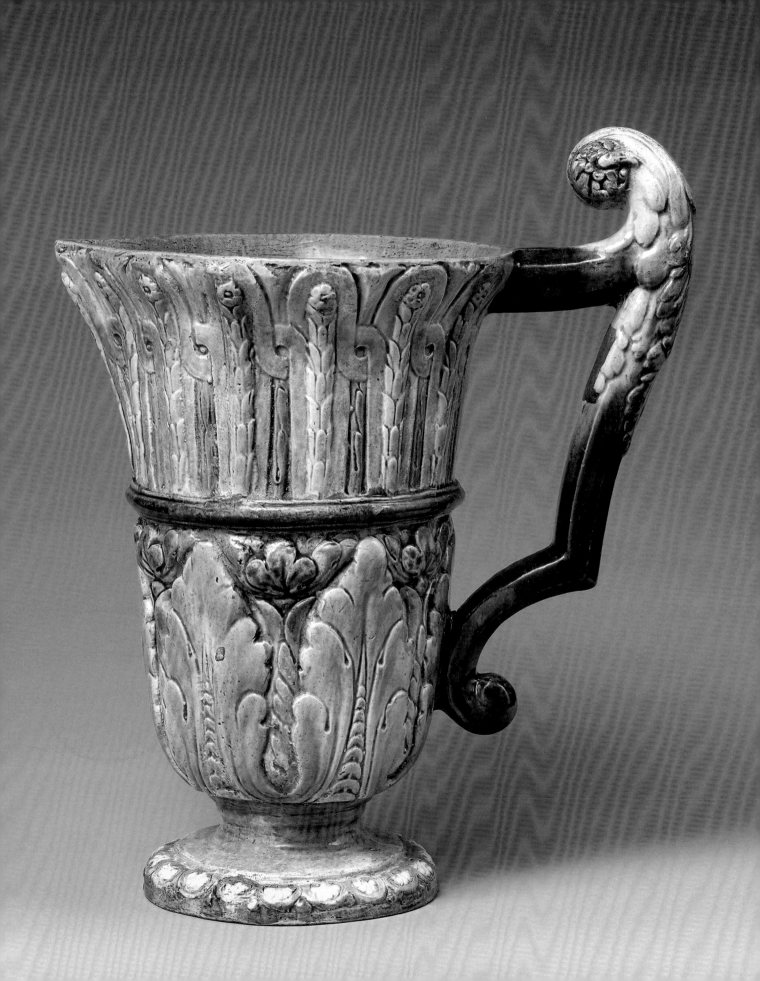

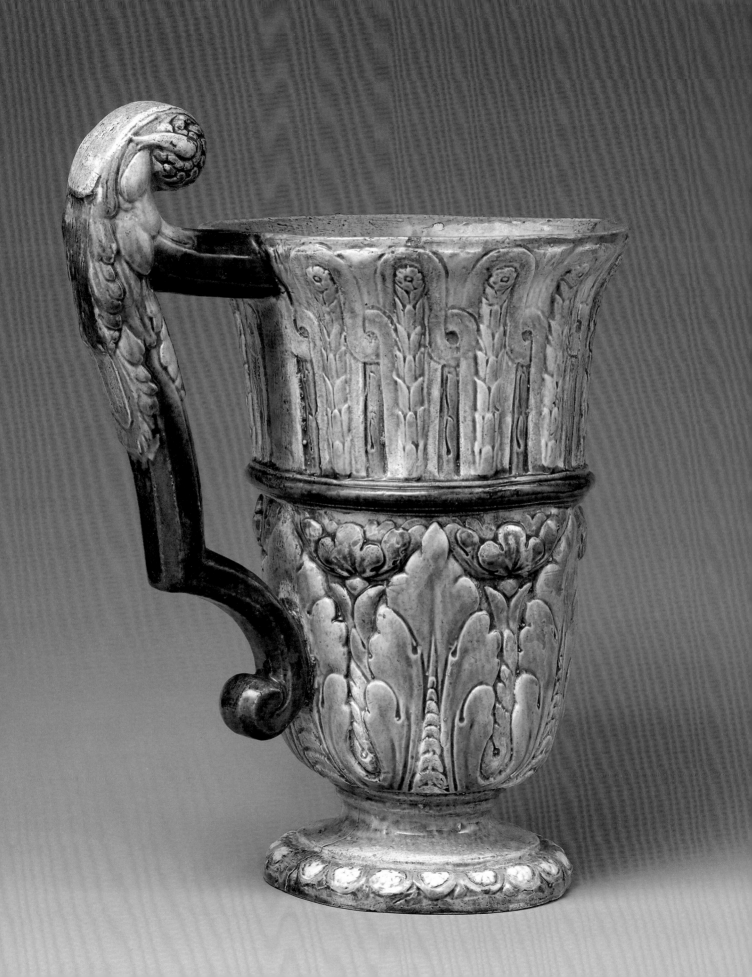

20

SAXON

Tankard
Late 16th or 17th century

Serpentine and silver-gilt mounts
H. 12 in. (30.5 cm), w. (with handle) 8½ in. (21.6 cm)
Marks (on the lid): *GH* or *CH*

Provenance: Henry Richard Greville (1779–1853),
3rd Earl of Warwick and Brooke, Warwick Castle;
by descent through his line; Galerie Neuse,
Bremen; purchased by Alexis Gregory, 1998.

A hardstone known since antiquity, serpentine—likely named for its snakeskin appearance—was believed to protect against disease and neutralize poison, making objects in serpentine highly prized in the sixteenth and seventeenth centuries, before its value declined in the eighteenth century.[71] In Saxony, serpentine was mainly found near the city of Zöblitz, the epicenter of the production.[72] Serpentine turners—united in a guild since 1613—would turn a piece on a lathe. The shapes were usually inspired by the work of goldsmiths. The mountings were then set in silver or gold by goldsmiths.

This large tankard has two thin rings toward the base. The band in the middle of the body is gilded like the rest of the mounts and decorated with motifs such as acanthus leaves. The lid is composed of two convex ornaments with a dart frieze and has repoussé scroll motifs and masks. The *S*-shaped handle has an animal head—perhaps a dragon—modeled in the round. The lid is decorated with a pine cone. The marks *GH* or *CH* are visible in two places, but the goldsmith is not identified. Mounts were made to enhance the beauty of the stone. They also provided handles and spouts, as the material is extremely hard and cannot be carved. Several tankards that belonged to the Electors of Saxony—the princes who controlled the mining and production of serpentine—can still be found today in the Grünes Gewölbe (Green Vault) in Dresden.[73]

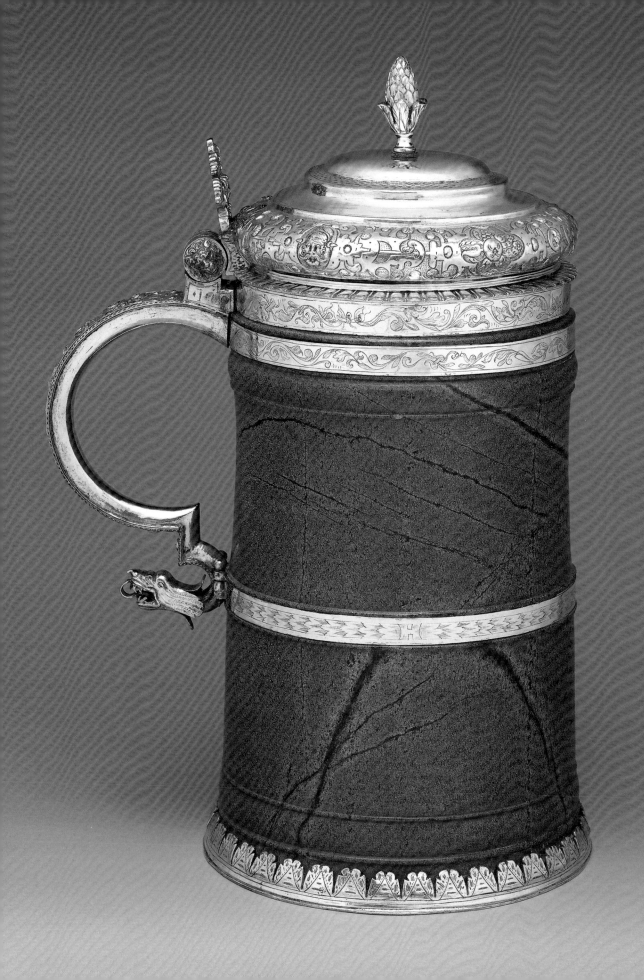

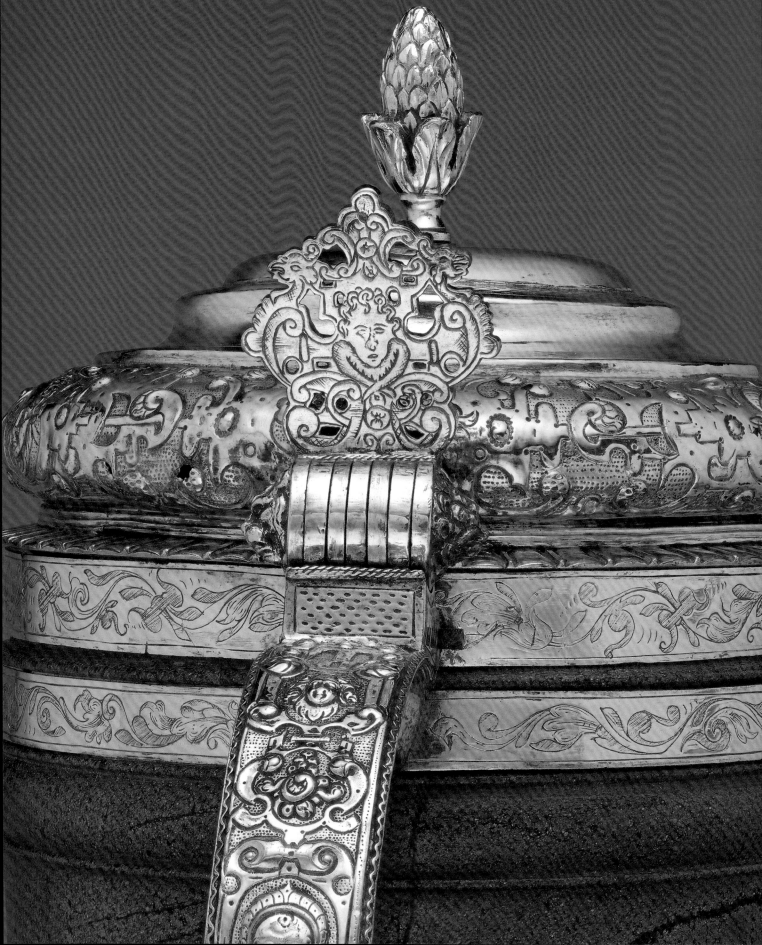

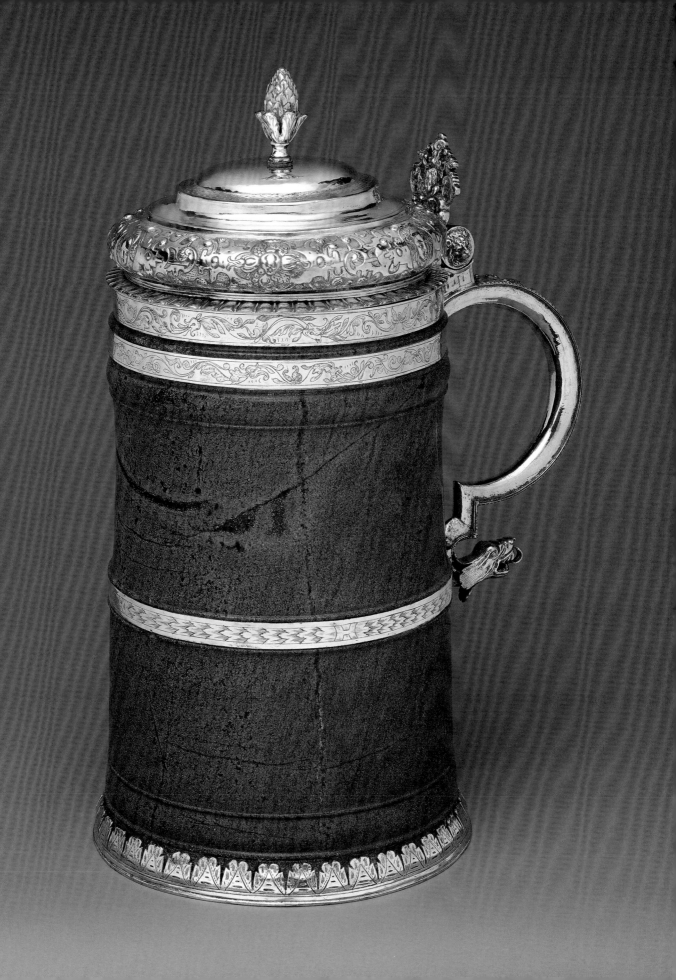

SOUTHERN GERMANY, POSSIBLY
GEORG PFRÜNDT (1603–1663)
Carved Cup
2nd half of 17th century

Rhinoceros horn
H. 9 in. (23 cm), DIAM. (base) 4¾ in. (12 cm)

Provenance: Sale, Sotheby's, London,
December 12, 1985 (lot 290); Antony Embden,
Paris; purchased by Alexis Gregory, Paris, date
unknown.

Carved cups made from exotic materials were highly sought after during the sixteenth and seventeenth centuries. Made in three parts and carved from rhinoceros horn, this cup depicts a procession in which the main figure, probably a king or a prince, is surrounded by ancillary figures, likely servants. The main figure wears a tunic, necklaces, and a crown and holds a staff in his left hand. One of the attendants is fanning him. Several figures are holding or playing musical instruments, while others, accompanied by a goat, carry a dish and a ewer for what seems to be a banquet. The bottom part of the body of the cup is decorated with garlands of fruit, and the foot of the cup depicts several men hunting an elephant and a rhinoceros.

At the time of this cup's making, rhinoceros and "unicorn" horns—likely narwhal tusks—were believed to be antidotes to poison. As a result, there was a robust trade not only in horns and narwhal tusks but also in bezoars.[74] Among the prominent figures known to have possessed mounted and carved rhinoceros horns are Emperor Rudolf II (r. 1576–1612), Cardinal Flavio Chigi (1631–1693), and Duke Ferdinando Gonzaga (1587–1626).[75] Horns were often carved into drinking vessels and sometimes mounted with gilt by goldsmiths. One of the most important ivory and horn carvers in southern Germany at that time was Georg Pfründt.[76] Born in Flachslanden, near the city of Nuremberg, Pfründt worked in the workshop of the ivory carver Leonhard Kern (1588–1662). About 1638, Pfründt moved to France, plying his trade in Strasbourg, Lyon, and Paris, where he worked with Jean Warin (1606–1672). He later returned to southern Germany, where he worked in Regensburg, Heidelberg, and Stuttgart or Durlach. He also worked as an engraver and medalist; he was responsible for the design and casting of a medal dated 1661 that depicts Karl I Ludwig of Wittelsbach (1617–1680), Elector Palatine (1649–80). This cup may have been made to fit within a more complex and ornamented cup that was likely displayed in a Kunstkammer.[77] Several similar objects—cups carved in rhinoceros horn, attributed to Pfründt or his circle, and with a similar iconography—are in public collections, among them, the Grünes Gewölbe (Green Vault) in Dresden,[78] the Schatzkammer in Munich,[79] and the Museumslandschaft Hessen in Kassel.[80]

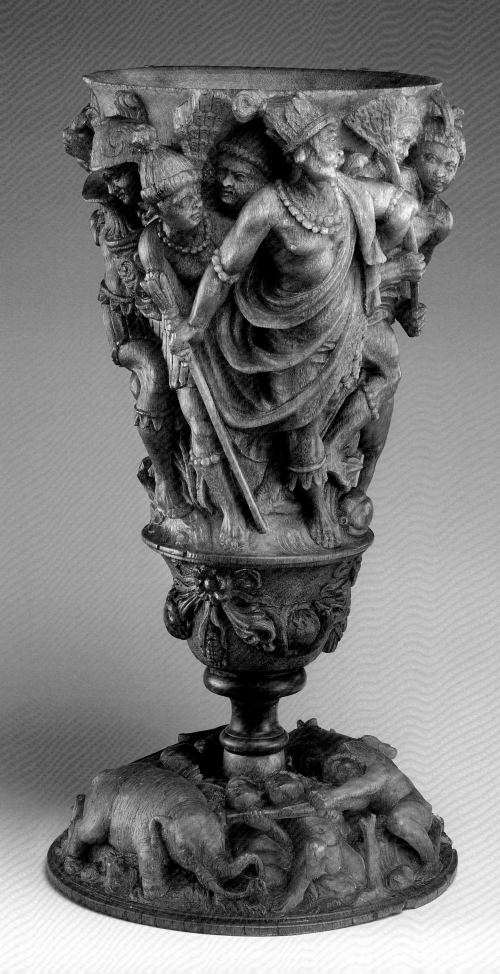

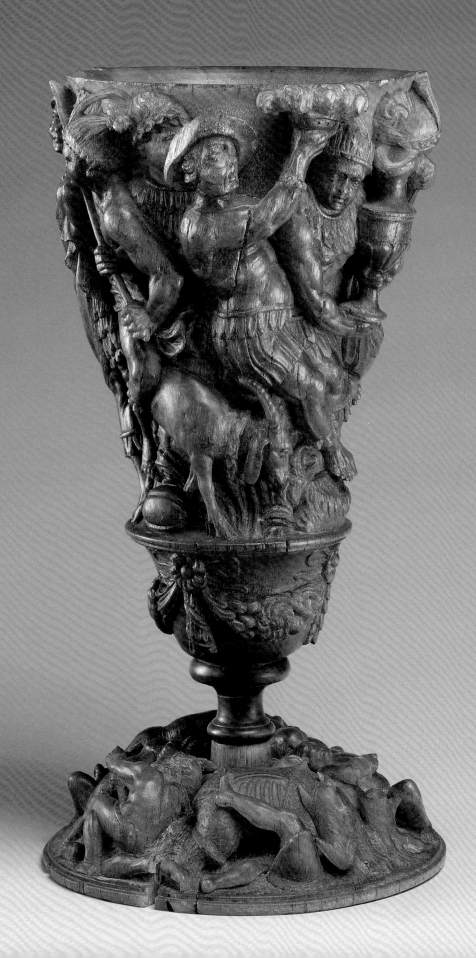

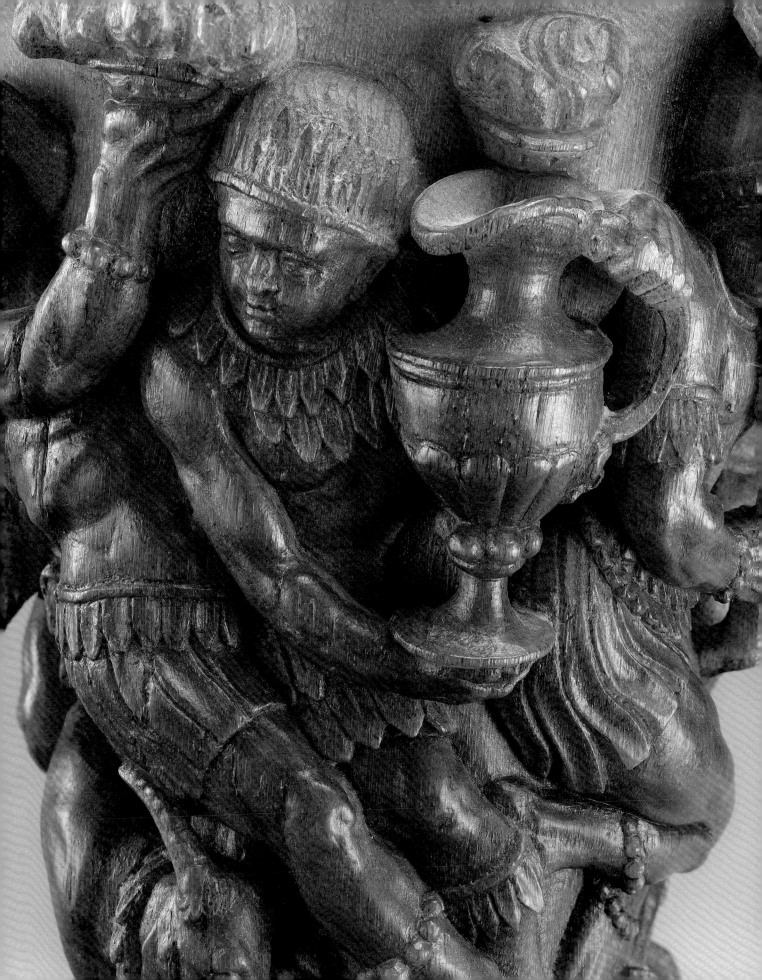

EUROPEAN

Figure of a Blessing Christ
Possibly 17th or 19th century

Gold, enamel, and diamonds
H. 4⅞ in. (12.4 cm), w. 2⅛ in. (5.4 cm),
D. 5¹/₁₆ in. (3.3 cm)

Provenance: Maurice-Yves Sandoz (1892–1958),
Burier (Château de Burier); Sydney J. Lamon
(d. 1973), New York; sale, Christie's, London,
November 28, 1973 (lot 18); Ruth Blumka
(1920–1994), New York; Blumka Gallery,
New York; purchased by Alexis Gregory, 2017.

Depicted here as a child, Christ stands with his right hand raised in blessing and a bouquet of gold flowers in his left hand (although roses are not often associated with the figure of Christ). He wears a long flowing red gown, with a green and yellow collar and hem, and a gilt-silver necklace with diamonds around his neck. The face, hands, and feet are made of white opaque enamel, while the gown is made of red and green enamels. A great attention to detail can be seen in the nails, which are painted, and the eyes, which are rendered in blue enamel. The bouquet was probably enameled, as there are traces of color—green, white, red, and blue. The curls and the back of the figure are mostly flat, which suggests that it was positioned against a flat surface, perhaps in a niche. It was likely part of a larger ensemble, possibly a large frame or a reliquary.

The technique used to create the figure was enameling in *ronde-bosse*. Parisian goldsmiths were masters of this technique, which was introduced at the end of the fourteenth century and reached its peak about 1400. Painted enamels, translucent or opaque, would be applied with a brush or painted on copper, silver, or gold. Red translucent enamel, also known as *rouge cler*, could only be applied on gold.[81] Sculptures—often enriched with jewels—were later included in devotional or profane compositions.

The present figure was previously linked to Spanish and Italian workshops. However, the technique used and several elements of this figure—for instance, the hair, eyes, and gown—raise questions about the time and place of its making.[82] The extensive use of translucent red on the gown may indicate that the figure was created later. According to Benvenuto Cellini (1500–1571), *rouge cler* was extremely difficult to obtain, even later in the sixteenth century, and used parsimoniously.[83] During the nineteenth century, Austrian and German goldsmiths such as Salomon Weininger (1822–1879) and Reinhold Vasters (1827–1909) used similar techniques to imitate or counterfeit objects from the Renaissance.[84] Their work betrays a nineteenth-century taste as they would often misunderstand certain techniques employed during the Renaissance.

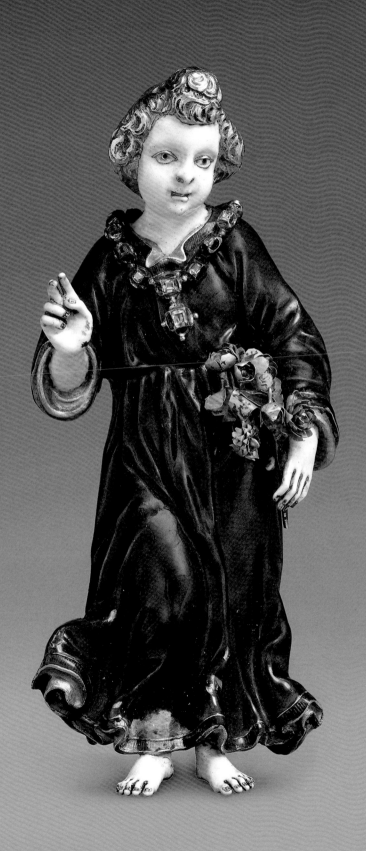

23

ATTRIBUTED TO DOMENICO
CUCCI (ca. 1635–1705) AND
WORKSHOP
Figure of Louis XIV
Manufacture des Gobelins, Paris,
1662–64

Gilt bronze and porphyry
H. 18½ in. (47 cm), L. 10¾ in. (27.3 cm),
W. 15¼ in. (38.7 cm)

Provenance: Louis XIV, Galerie d'Apollon,
Palais du Louvre, Paris; Louis XIV, Galerie des
Ambassadeurs, Palais des Tuileries, Paris; Louis
XV, Salle des Gardes, Palais du Louvre, Paris;
Cabinet Royal d'Histoire Naturelle, Paris; Nadault
de Buffon; sale, Drouot, Paris, March 5–6, 1883
(lot 151); H. Schneider, 1883; Wildenstein collection;
sale, Christie's, London, December 15, 2005 (lot
195); Jermyn Antiques, London; Kugel Gallery,
Paris; purchased by Alexis Gregory, 2007.

This gilt bronze depicts Louis XIV (1638–1715) wearing armor and a draped cloak. He is seated on a lion's pelt and holds a scepter in his right hand. In his left hand, he holds an Apollo shield, one of his emblems. The upper part of the shield—likely representing a crown—has been partially erased, as was often the case for symbols of the monarchy during the French Revolution. The lion's pelt—associated with Hercules—as well as the porphyry rock and the scepter were added later.

Although the authorship of this bronze and the cabinet it was destined for is debated, the bronze can be attributed to Domenico Cucci and his workshop.[85] Cucci was one of the most talented cabinetmakers during the reign of Louis XIV.[86] Born near Todi in Italy, he was invited to come to France around 1660 with his cousin, the sculptor Philippe Caffiéri (1634–1716), by Cardinal Jules Mazarin (1602–1661), the influential first minister and the king's godfather, as well as a discerning collector. At the Manufacture des Gobelins, Cucci and Caffiéri worked under the supervision of Charles Le Brun (1619–1690). This bronze sculpture may have been part of the so-called Cabinet of Apollo made after designs by Le Brun. The cabinet is described in the general inventories of the royal furnishings of 1681 and 1729.[87] A gilt-bronze figure representing Louis XIV driving his chariot crowned Cucci's cabinet. The Cabinet of Apollo and its pendant, the Cabinet of Diana, were the first works of art produced for the king, whose personal reign began in 1661. The pair was delivered to the Louvre's Galerie d'Apollon in 1664, only a few years after the fire that had destroyed the gallery.

The subjects depicted on the cabinets were intended to celebrate the king's glory at the close of a lengthy war against Spain. The Peace Treaty of the Pyrenees, negotiated by Mazarin and signed in 1659, sealed the alliance between the two kingdoms through the marriage of the king in 1660 to his double first cousin, the Infanta Maria Theresa of Austria (1638–1683), daughter of Philip IV of Spain (1605–1665).

Due to changing tastes, the Cabinets of Apollo and Diana were dismantled in 1747. The minerals and hardstones were removed from them to be displayed at the Cabinet Royal d'Histoire Naturelle in Paris.[88] The pair—and most cabinets made for Louis XIV—were sold in 1741 and 1751.[89] This bronze is one of the very few extant remnants of cabinets made by Cucci and the Gobelins workshop, nearly all of which have been dispersed or destroyed. Of the six gouaches created for the Cabinets of Apollo and Diana, the three existing gouaches painted in 1663 by Joseph Werner (1637–1710) during one of his trips to Paris are in the collection of the Château de Versailles. Two surviving bronze medallions executed by Samuel Frei are now in a private collection.[90]

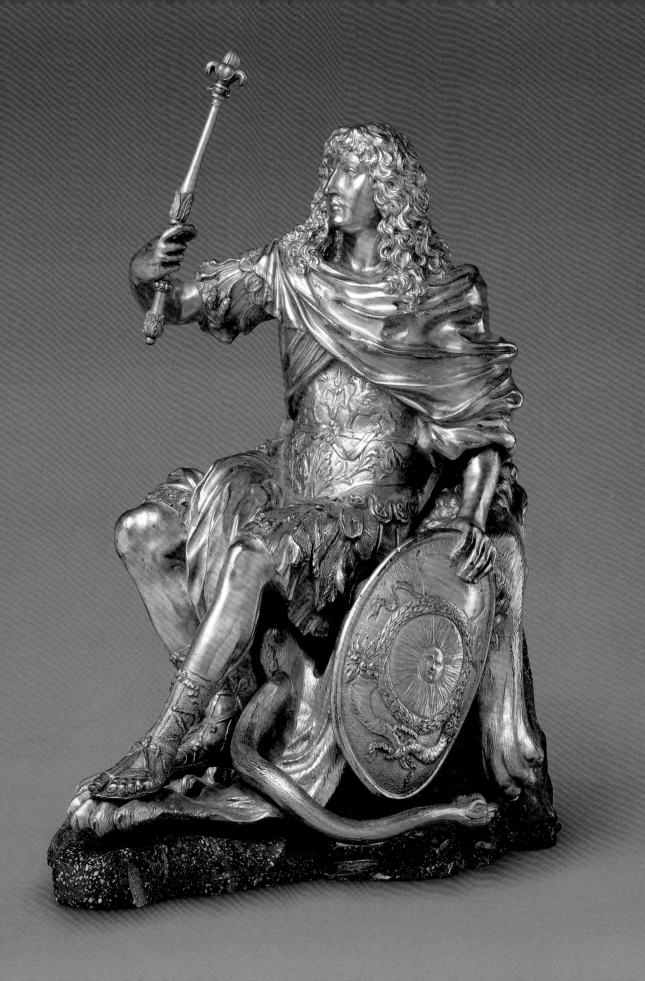

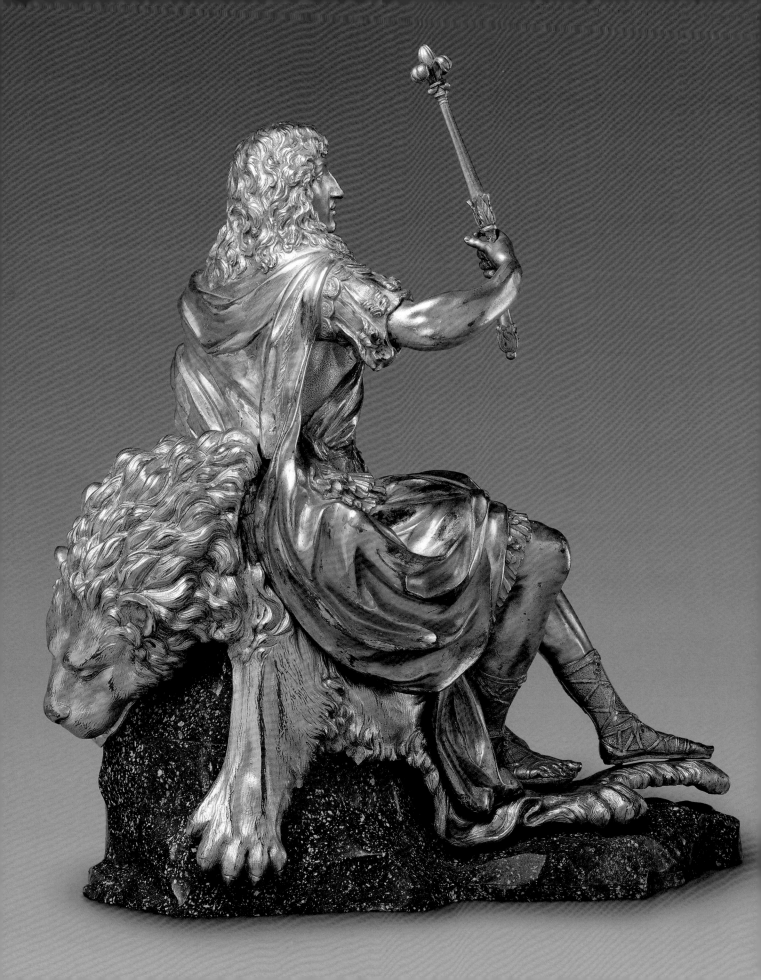

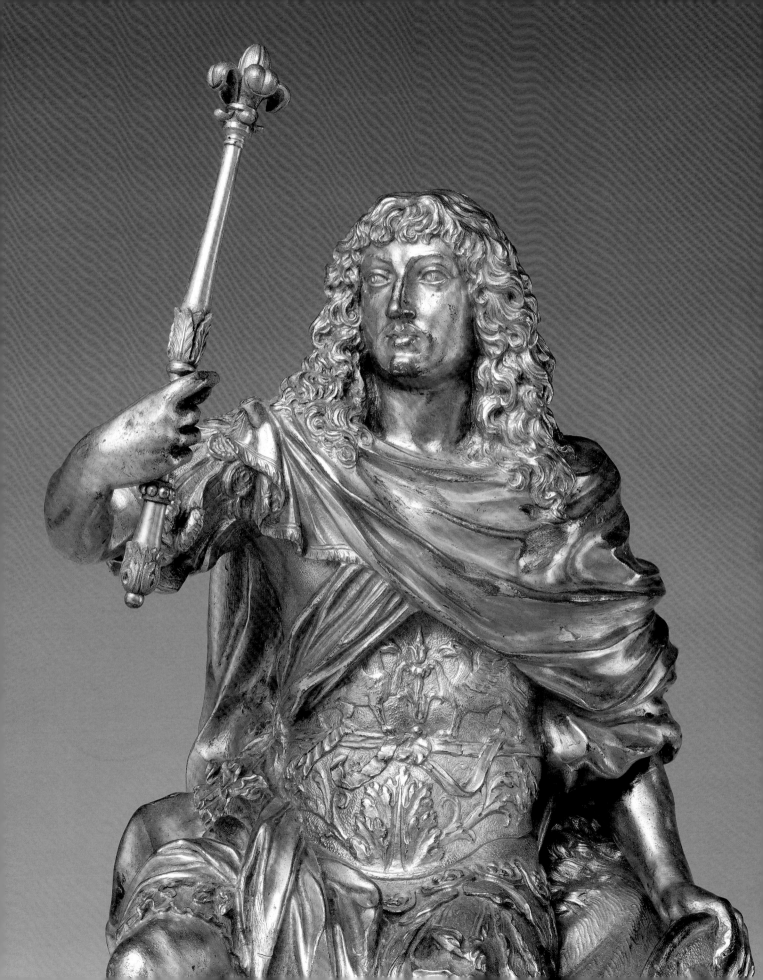

24

SOUTHERN GERMANY, POSSIBLY
JOHANN MICHAEL MAUCHER
(1645–1701)
Hilt
ca. 1700

Ivory
H. 6¼ in. (16 cm), w. 5½ in. (14 cm),
D. ¾ in. (2 cm)

Provenance: Augusta Sibylla, Margravine of
Baden-Baden née Saxe-Lauenburg (1675–1733); by
descent to her line until extinction of the Baden-
Baden line in 1771; bequeathed to Empress Maria
Theresa (1717–1780); sale of the collections of
Augusta Sibylla, Margravine of Baden-Baden,
Offenburg, May 8, 1775 (lot 217); Karl Friedrich
of Baden-Durlach (1728–1811), Baden-Baden;
by descent to Grand Duke Friedrich I of Baden
(1826–1907), 1883;[91] by descent to his son Grand
Duke Friedrich II of Baden (1857–1928) until his
abdication in 1918, Baden-Baden; Neues Schloss,[92]
Baden-Baden; sale of the collection of the
Margraves of Baden, Baden-Baden, Sotheby's,
October 5–21, 1995 (lot 306); purchased by Alexis
Gregory, New York, 1995.

Johann Michael Maucher belonged to an illustrious dynasty of ivory carvers from Schwäbisch Gmünd, a city between Nuremberg and Stuttgart.[93] Maucher probably began his apprenticeship with his father, Georg Maucher (1604–1680), when he was about twelve years old. Made primarily between 1670 and 1690, most of his production consists of small objects—ewers, basins, flasks, knives, and ivory panels decorating rifles—for wealthy patrons such as the dukes of Württemberg and Pfalz-Zweibrücken and Prince Johann Adam Andreas von Liechtenstein (1662–1712).[94] Maucher was also known for his work as a sculptor: between 1681 and 1688, he received payments for sculpted figures and altars intended for several churches, signing many of his works as *Bildhauer und Bixenshifter* (sculptor and gunstock maker).[95] He had a flourishing workshop but was forced to leave Schwäbisch Gmünd in 1688, when he was convicted of counterfeiting money, an offense punishable by death.[96] He settled in Augsburg and in 1693 left for Würzburg, where he remained until his death.

The scene depicted on this ornately carved hilt is a hunt, with interlocking horses, dogs, bears, elk, wild boars, rams, antelope, and foxes. Each of the hilt's three distinctive parts—the grip, the guard, and the rain guard—is secured with dowels. Hunting chases are a recurrent theme in the production of Maucher, as well as those in his circle, and for these he often used engravings by Adriaen Collaert (ca. 1560–1618), Johann Wilhelm Baur (1607–1642), Jost Amman (1539–1591), and Philip Galle (1537–1612) as models.[97] The intricate and delicate carving demonstrates a mastery of the art of ivory carving. Ivory in Europe came primarily from African elephants, as the pale color and workability of their tusks were highly favored. No part of the tusk was wasted. It would either be carved—yielding sculptures, cups, flasks, saltcellars, and the like—or used as an oliphant (a horn or trumpet). Ivory could also be integrated into weapons such as rifles and sword hilts. This hilt is described in an eighteenth-century inventory as a "couteau de chasse d'ivoire, artistiquement tourné" (ivory hunting knife, artistically made).[98] The knife was likely not intended for use but rather was created to be displayed in a Kunstkammer. A stylistically similar one from the collection of Johann Wilhelm (1658–1716), Elector Palatine (1690–1716), is in the Bayerisches Nationalmuseum in Munich.[99] It is part of a set of three knives, including a hunting knife and a scabbard in leather.[100]

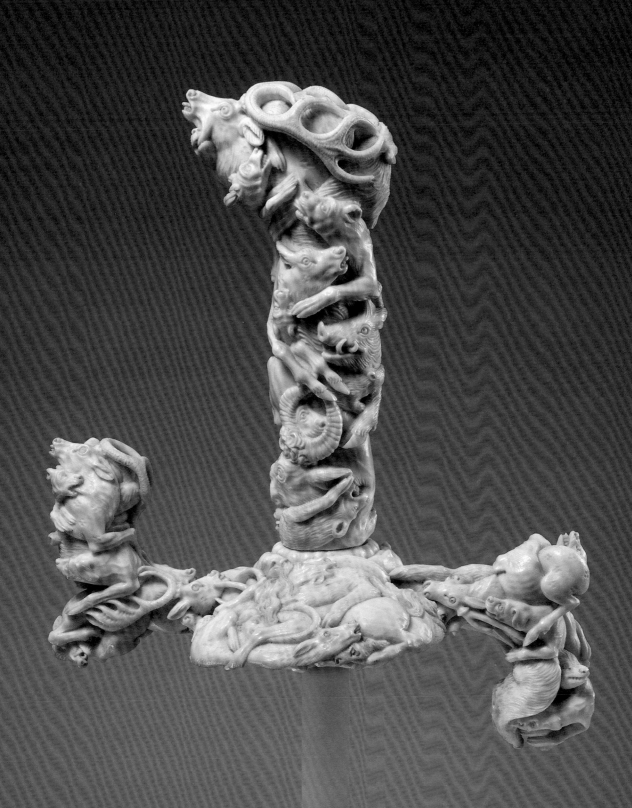

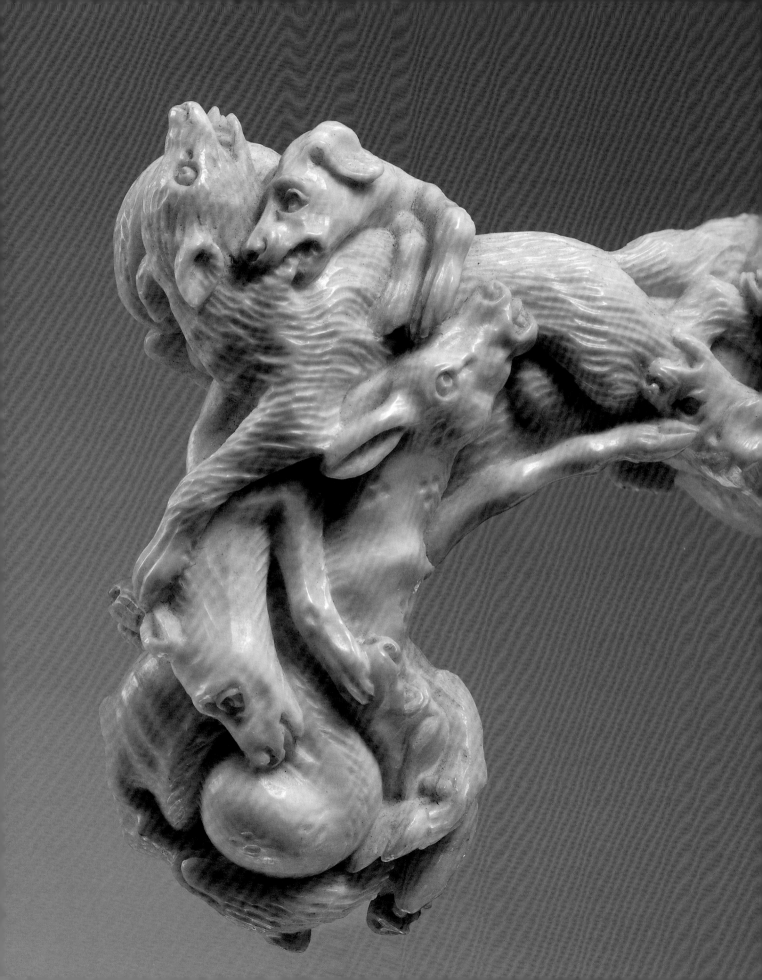

Paris 2004
Elisabeth Taburet-Delahaye, ed. *Paris 1400: Les arts sous Charles VI.* Ex. cat. Paris (Musée du Louvre), 2004.

Pointon 1999
Pointon, Marcia. "Dealer in Magic: James Cox's Jewelry Museum and the Economics of Luxurious Spectacle in Late-Eighteenth-Century London." *History of Political Economy* 31 (1999): 423–51.

Pradère 1989
Pradère, Alexandre. *Les ébénistes français de Louis XIV à la Révolution française.* Paris, 1989.

Razzall 2021
Razzall, Rosie. "Die Künstlerin Rosalba Carriera (1673–1757) und ein aussergewöhnlicher Gebrauch der Dreikönigenzettel." *Kölner Domblatt. Jahrbuch des Zentral-Dombau-Vereins* (2021): 242–55.

Sani 1985
Sani, Bernardina. *Rosalba Carriera: Lettere, diari, frammenti.* 2 vols. Florence, 1985.

Sani 2007
Sani, Bernardina. *Rosalba Carriera 1673–1757: Maestra del pastello nell'Europa ancien régime.* Turin, 2007.

Smith 2000
Smith, Roger. "James Cox (c. 1723–1800): A Revised Biography." *Burlington Magazine* 142 (June 2000): 353–61.

Smith 2008
Smith, Robert. "The Sing-Song Trade Exporting Clocks to China in the Eighteenth Century." *Antiquarian Horology* 30, no. 5 (March 2008): 629–58.

Stark 2003–4
Stark, Marnie P. "Mounted Bezoar Stones, Seychelles Nuts, and Rhinoceros Horns: Decorative Objects as Antidotes in Early Modern Europe." *Studies in the Decorative Arts* 11, no. 1 (Fall/Winter 2003–4): 69–94.

Toutain-Quittelier 2017
Toutain-Quittelier, Valentine. *Le Carnaval, la Fortune et la Folie: La Rencontre de Paris et Venise à l'Aube des Lumières.* Rennes, 2017.

Utrecht 2010
Bob van Wely, Anne-Sophie van Leeuwen, Marieke Lefeber-Morsman, Roger Smith, Guo Fuxiang, and Guan Xueling, eds. *SingSong: Schatten uit de Verboden Stad / Treasures from the Forbidden City.* Ex. cat. Utrecht (Museum Speelklok), 2010.

Verdier 1962
Verdier, Philippe. "Les Sibylles dans l'émaillerie limousine." *Bulletin de la société archéologique et historique du Limousin*, no. 89 (1962): 197–98.

Verdier 1967
Verdier, Philippe. *The Walters Art Gallery: Catalogue of the Painted Enamels of the Renaissance.* Baltimore, 1967.

Verdier and Focarino 1977
Verdier, Philippe, and Joseph Focarino. *The Frick Collection: An Illustrated Catalogue.* Vol. 8, *Limoges Painted Enamels, Oriental Rugs, and English Silver.* New York, 1977.

Vignon 2015
Vignon Charlotte, *The Frick Collection Decorative Arts Handbook.* New York, 2015.

Wardropper 2015
Wardropper, Ian, with Julia Day. *Limoges Enamels at The Frick Collection.* London, 2015.

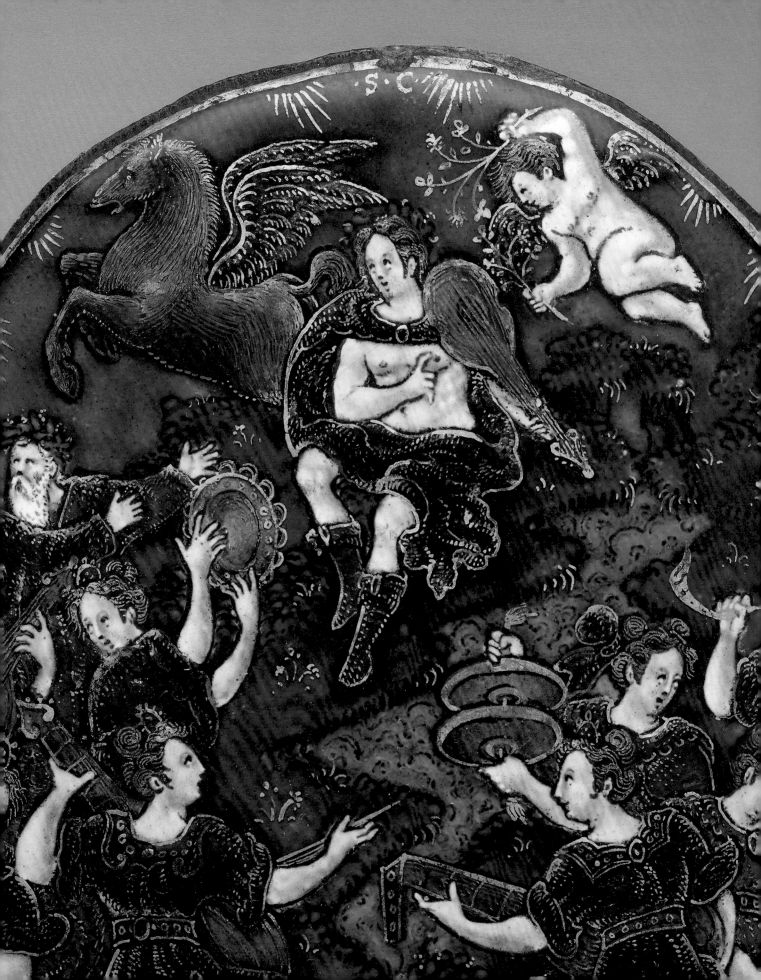

INDEX

Page numbers in bold refer to illustrations.

dell'Abate, Nicolò 74
Absalom 58
Agony in the Garden **52**
d'Albret, Jeanne 70
Amman, Jost 94
Amphitrite 58
Antoninus Liberalis, *Metamorphoses* 74
Apollo and the Muses 30, **32**, **74**, 110
Arnhold, Henry 11
Augustus II ("the Strong"), Elector of Saxony
 and King of Poland 15, 98
Augustus III, Elector of Saxony and King of
 Poland 98
Augustus, brother to Christian II and Johann
 Georg I, Electors of Saxony 18
automatons 12, 106, 108
d'Avaux *see* Mesmes family

Ballarin, Zuane (Giovanni) 18
Baur, Johann Wilhelm 94
biberon 6, 22, **23–25**
Biener, Hans 18
Blanchon, Joachim 30, 110
Bloch, Henry W. and Marion H. 12
de Bourbon, Charles 30
Boyne, Gustavus Hamilton, 2nd Viscount 104
Boyvin, René 22, 40, 42
 Jason Confronts the Dragon **42**
 Jason Throws a Rock at the Giants **42**

Cabinet of Apollo, Cabinet of Diana *see*
 Galerie d'Apollon
Caffiéri, Philippe 90
Cain killing his brother Abel 70
Canticle of Canticles 46
Carriera, Rosalba 6, 15, 102, 104
 Portrait of a Man in Pilgrim's Costume
 (cat. 27) **105**
 Portrait of a Woman (cat. 26) **16**, **104**
Cellini, Benvenuto 76, 88, 111
du Cerceau, Jacques Androuet 22, 58
Chigi, Cardinal Flavio 84
Christ as a child 12, 52, 66, 88, **89**
Christian II, Elector of Saxony 18
Clara, Miss 106
clocks **8**, 11, 12, 14, **99–101**, 106, 108, 111

Clouet, François 30
Collaert, Adriaen 94
Cotes, Francis 15
Court dit Vigier, Jean 30, 34, 36
 Plaque: *Jupiter under a Canopy* (cat. 4) 30,
 31, 32, **33**
 Plate: *Jupiter on a Chariot* (cat. 5) **35**
 Plate: *Saturn on a Chariot* (cat. 6) **37**
de Court, Jean *see* Master I.C.
de Court, Suzanne 15, 74
 Oval Medallion: *Apollo and the Muses*
 (cat. 18) **75**, **116**
Courteys, Martial 54
 Calendar Plate for May (attr., cat. 12) **54–55**
Courteys, Pierre 30, 36, 48
Cousin the Elder, Jean 22
Cox, James 14, 15, 106, 108, 111
 Musical Automaton Rhinoceros Clock
 (cat. 28) **107**, **109**
Crown Jewels of Portugal 15
Crucifixion 52, 66, **68–69**
Cucci, Domenico 14, 90, 111
 Figure of Louis XIV (attr., cat. 23) **2**, **91–93**
cups 12, 18, 48, 58, 84
de Caramellis, Don Bernardino 18

Delaune, Etienne 22, 30, 32, 54, 74
 *Jupiter under a Canopy (Suite de grotesques
 avec des divinités)* 32
 The Labors of the Months: May **32**
Dinglinger, Johann Melchior 98
dishes 12, 13, 18, **19**, **21**, 30, 36, 40, 42, 74, 84
Dolu, Geneviève 42
Dolu, Jean 42
Dürer, Albrecht 106
Duveen, Joseph 11

Edey, Winthrop Kellogg 11
enamels 6, 11, 12, 13, 15, 18, 30, 32, 48, 51, 52, 60,
 64, 66, 70, 74, 88, 106, 110
European (cat. 22) 84, **85**
ewers 6, 12, 13, 18, 22, **23–25**, 70, 74, 76, **77–79**,
 84, 94

faience 11, 12
Fall of Manna 58
de' Ferrara *see* Giolito, Gabriele
Fiorentino *see* Rosso
Fontainebleau, School of 76
 Ewer (possibly; cat. 19) **77–79**
Forbidden City, Beijing 15, 111
Foresti, Alba 102
Francis I of France 40, 76
Francis II of France 30
Frei, Samuel 90, 111
French (School) (cat. 11) 52, **53** (cat. 16) 66, **67**
Frick, Henry Clay 6, 11
Fugger family 18

Galerie d'Apollon, Louvre 90
Galerie d'Ulysse, Fontainebleau 74
Galle, Philip 94
Geyger, Johann David 98
Ghisi, Giorgio 74
gilt bronze 11, 12, 14, 90, 98
Giolito, Gabriele, de' Ferrara 34
 Jupiter 34
 Saturn 34
Giulio Romano 22
Gobelins 14, 90
de Gohory, Jacques 40
Golden Fleece, Order of the 40, 42
von Goldschmidt-Rothschild, Baron Max 26
Gonzaga, Duke Ferdinando 84
Gonzaga, Francesco, Bishop of Mantua 66
Gregory, Alexis 6, 7, 11, 12, 13, 14, 15, 102, 104
Gregory, Peter 15
Greuze, Jean-Baptiste 15
Grünes Gewölbe, Dresden 15, 98, 111

Henry II of France 22
Horowitz, Vladimir 11
hilts 6, 12, 13, 94, **95–97**

Immaculate Conception 46, 110
ivories 6, 11, 12, 13, 14, 84, 94

Jason 40, 42, 110
Jethro 58
Johann Georg I, Elector of Saxony 18
Johann Wilhelm, Elector Palatine 94
Joshua 70
Jupiter 30, 32, 34, 36

Karl I Ludwig of Wittelsbach 84
Kern, Leonhard 84
Kerver, Thielman 46
Knafel, Sidney R. 11
Köhler, Johann Heinrich 14, 15, 98
 Parade Clock with Cameos (attr., cat. 25)
 8, 99–101

Labors of the Months 54
Le Brun, Charles 90
van Leyden, Lucas 52
 The Agony in the Garden **52**
von Liechtenstein, Johann Adam Andreas 94
Limoges 6, 11, 12, 13, 15, 26, 30, 34, 40, 46, 48,
 52, 54, 58, 66, 70, 74
Limosin, Léonard 66, 70
Litanies of the Blessed Virgin 46
Livre de la Conqueste de la Toison d'or 40
Lot 48, 51
Louis XIV **2**, 11, 14, 90, **91–93**

Maison André, Paris 18
Maria Josepha, wife to Augustus III of Saxony
 98
Maria Theresa of Austria, Infanta 90
Marmi, Anton Francesco 104
Mary, Queen of Scots 30, 36
Master I.C. (identified as Jean Court or de
 Court) 13, 15, 30, 34, 36, 48, 51, 74, 110
 Cup: *Lot and His Daughters* **51**
 Plaque: *Jupiter under a Canopy* (cat. 4) 30,
 31, 32, **33**
 Plate: *Jupiter on a Chariot* (cat. 5) **35**
 Plate: *Saturn on a Chariot* (cat. 6) **37**
Maucher, Georg 94
Maucher, Johann Michael 14, 94
 Hilt (possibly; cat. 24) **95–97**
de Mauregard, Jehan (Jean) 40
Mazarin, Cardinal Jules 90
Medea 40
de' Medici, Caterina 22
Mentmore Towers 15, 58
Merlin, John Joseph 106
de Mesmes, Henri 42
de Mesmes, Jean-Jacques 42
Mesmes family 42
Middlesex, Charles Sackville, Earl of, later 2nd
 Earl of Dorset 104
Modestini, Dianne Dwyer 11
Montmorency-Laval family 22

Morgan, J. P. 6, 11
Moses 58, 70
Muses 30, 32, 74, 110

Oudry, Jean Baptiste 106

Palais des Tuileries 22, 90
Palissy, Bernard 12, 22, 76, 110
Paradin, Claude 48, 58, 60
 Tazza: *Les Quadrins historiques de la Bible:
 Exodus XVII* 48, 58, **60**
pastels 9, 12, 102, 104, 111
Pausanias, *Description of Greece* 74
Pencz, Georg 34, 36
 Plate: *The Seven Planets (Jupiter)* **36**
 Plate: *The Seven Planets (Saturn)* **36**
Pénicaud, Jean II 26, 52
 Plaque: *The Agony in the Garden* **52**
Penni, Luca 74
 Apollo and the Muses **74**
Petrarch, *Trionfi* 26
Pfründt, Georg 84
 Carved Cup (possibly; cat. 21) **85–87**
Philip III ("the Good") of Burgundy 40
Phillips, Ambrose 104
de Pisan, Christine, *Cent Ballades* 26
plaques 26, 30, **31**, **33**, 46, 52, 74
plates 34, 35, 36, **37–39**, **41**, **43–45**, 54
pomanders 12, 64
Portinari family 18
Primaticcio, Francesco 74, 76

Qianlong emperor 15

Raimondi, Marcantonio 26, 28, 74
Raphael 9, 26, 74
Reymond, Martial 30, 32
 Dish: *Apollo and the Muses; Fame*
Reymond, Pierre 13, 26, 40, 42, 48, 58, 70, 110
 Circle of
 Saltcellar (cat. 10) **49–50**
 Ewer (cat. 17) **71–73**
 Plaque: *The Litanies of the Blessed Virgin*
 (cat. 9) **47**
 Saltcellar (cat. 3) **27**, **29**
 Workshop of
 Casket: *Old Testament Subjects* **48**, **70**
 Dish: *Jason Confronting the Giants*
 (cat. 7) **41**
 Dish: *Jason Confronting the Dragon
 Guarding the Golden Fleece* (cat. 8) **10**, **43**
 Pair of Covered Tazzas (cat. nos. 13, 14)
 59, **61**

rhinoceroses 84, 106, **107**
rhinoceros horns 11, 12, 13, 84
de Roissi *see* Mesmes family

Romano *see* Giulio 22
Rosso Fiorentino 22, 40, 76
Rothschild family 15
Rubinstein, Arthur 11
Rudolf II, Emperor 84

Saint-Porchaire ware 6, 12, 22
Salomon, Bernard 48, 58, 60
saltcellars 26, **27**, **29**, 48, 110
Salvati family 18
Saturn 34
Saxon (School) (cat. 20) 18, 80, **81–83**
Schongauer, Martin 52
Séguier, Pierre 58, 110
serpentine 12, 80, 111
Sheba, Queen of 58
sibyls 66
Sisley, Alfred, *L'Écluse de Saint-Mammès* 12
South German (School) (cat. 15) 64, **65**; see
 also Maucher, Johann Maucher; Pfründt,
 Georg
Stanza della Segnatura, Vatican 74
Stoody Hayes, Nevada 15
Stravinsky, Igor 11
Sullivan, Melinda and Paul 11

tankards 12, 80, **81–83**
Tasca, Catherine 12
tazzas 34, 36, 58, 60
Thiry, Léonard 22, 40, 42
 Jason Confronts the Dragon 42
 Jason Throws a Rock at the Giants 40
de Tournes, Jean 48, 60

Vasters, Reinhold 88, 111
Venus 26, 36
Versailles, Château de 90
Vico, Aeneas 36
Vigée-LeBrun, Elisabeth Louise 15
Vigier *see* Master I.C. (Jean de Court)
Virgil, *Aeneid* 26

Warin, Jean 84
Weininger, Salomon 88
Werner, Joseph 90
de Wolfe, Elsie 11

Zeno, Pier Caterino 104
Zöblitz 80

IMAGE CREDITS

Photographs have been provided by the owners or custodians of the works. The following list applies to those photographs for which a separate credit is due.

Cat. nos. 1–28: Joseph Coscia Jr.

Fig. 1: © His Majesty King Charles III 2022

Fig. 2: © Victoria and Albert Museum, London

Figs. 5a–b: © The Trustees of the British Museum